INNESS

Landscapes

INNESS
Landscapes

by Alfred Werner

Watson-Guptill Publications/New York

Front cover: *Apple Blossom Time* (detail)
Courtesy of the Pennsylvania Academy of the Fine Arts
Bequest of J. Mitchell Elliott
(Full painting is reproduced on page 67)

Paperback edition, 1977, 1998

Published in 1998 in the United States by Watson-Guptill Publications,
a division of Billboard Publications, Inc.
1515 Broadway
New York, NY 10036

Library of Congress Catalog Card Number: 73-4559
ISBN 0-8230-2552-7 (pbk.)

Printed in Japan

1 2 3 4 5 6 7 8 9 / 03 02 01 00 99

To Judith

ACKNOWLEDGMENTS

I would like to express my appreciation to Don Holden and Stanley Appelbaum for their help and advice. I would also like to thank the staffs of the following twenty-six American museums and galleries who made available their color transparencies, many of which were shot especially for this book:

Addison Gallery of American Art, Phillips Academy, Andover, Massachusetts
Albright-Knox Art Gallery, Buffalo, New York
The Art Institute of Chicago, Chicago, Illinois
Baylor University Art Museum, Waco, Texas
Berkshire Museum, Pittsfield, Massachusetts
The Brooklyn Museum, Brooklyn, New York
California Palace of the Legion of Honor, San Francisco, California
Delaware Art Museum of the Wilmington Society of the Fine Arts, Wilmington, Delaware
The High Museum of Art, Atlanta, Georgia
J. B. Speed Art Museum, Louisville, Kentucky
Los Angeles County Museum of Art, Los Angeles, California
The Metropolitan Museum of Art, New York, New York
Montclair Art Museum, Montclair, New Jersey
Museum of Fine Arts, Boston, Massachusetts
National Gallery of Art, Washington, D.C.
Nelson Gallery-Atkins Museum, Kansas City, Missouri
The New Britain Museum of Art, New Britain, Connecticut
The Paine Art Center & Arboretum, Oshkosh, Wisconsin
Pennsylvania Academy of the Fine Arts, Philadelphia, Pennsylvania
The Phillips Collection, Washington, D.C.
Santa Barbara Museum of Art, Santa Barbara, California
Sterling and Francine Art Institute, Williamstown, Massachusetts
The St. Louis Art Museum, St. Louis, Missouri
Virginia Museum of Fine Arts, Richmond, Virginia
Wadsworth Atheneum, Hartford, Connecticut
Worcester Art Museum, Worcester, Massachusetts

1825	Born on a farm near Newburgh, New York, on May 1. Soon thereafter, his father, a prosperous grocer, moves with his family to New York City.
1830	The Inness family moves to Newark, New Jersey.
ca. 1841	Receives drawing lessons from John Jesse Barker. Is apprenticed to a firm of map engravers in New York City.
ca. 1843	Studies with the painter Régis François Gignoux.
1843	Marries Delia Miller, who dies a few months after the wedding.
1844	Exhibits in the National Academy of Design, New York City.
1844	Exhibits at the American Art Union, New York City.
1846	Opens his own studio in New York City.
1850	Marries Elizabeth Hart. The couple sail for Europe in 1850 or 1851.
1852	Return to the United States.
1853	Elected Associate Member of the National Academy of Design, New York City.
1854	Goes to Europe.
1855	Returns to the United States. Lives in Brooklyn, but has his studio in New York City.
1860	Moves to Medfield, a suburb of Boston, Massachusetts. After the outbreak of the Civil War, tries to enlist in the Union Army, but is rejected on account of his poor health.
1864	Leaves Medfield for Eagleswood, New Jersey.
1867	Moves to Brooklyn. Exhibits in the Paris Exposition.
1868	Elected Member of the National Academy of Design, New York City.
1870	Sails for Europe.
1872	Exhibits at the Royal Academy, London.
1873	Brief return to Boston where fire destroyed the galleries of his dealers.
1873–75	Sojourn in Europe.
1876	Resides in New York City.
1878	Moves to Montclair, New Jersey.
1884–88	Makes numerous journeys in the Western Hemisphere, including trips to Mexico City and Cuba.
1889	Exhibits at the Universal Exposition, Paris.
1891	Again exhibits at the Universal Exposition, Paris.
1892	Exhibits in Munich, Germany, where he receives a medal.
1894	Sails for Europe. Dies on August 3 at the Scotch town of Bridge-of-Allan. Funeral at the National Academy of Design, New York City, on August 23.

The author is profoundly indebted to the researches made by the late LeRoy Ireland and by Professor Nicolai Cikovsky, Jr., whose volumes contain lengthy bibliographies. Listed below are books on Inness and on nineteenth-century American art that are easily accessible to the general reader.

Baigell, Matthew, *History of American Painting*. New York: Praeger Publishers, Inc., 1971.

Baker, Virgil, *American Painting: History and Interpretation*. New York: The Macmillan Company, Inc., 1950.

Born, Wolfgang, *American Landscape Painting: An Interpretation*. Westport: Greenwood Press, Inc., 1948.

Cikovsky, Nicolai, Jr., *George Inness*. New York: Praeger Publishers, Inc., 1971.

Daingerfield, Elliott, *George Inness, The Man and His Art*. New York: Frederick Fairchild Sherman, 1911.

Eliot, Alexander, *Three Hundred Years of American Painting*. New York: Time, Inc., 1957.

Flexner, James T., *Nineteenth Century American Painting*. New York: G. P. Putman's Sons, 1970.

Gerdts, William H., *Painting and Sculpture in New Jersey*. New Jersey: Rutgers University Press, 1964.

Green, S. M., *American Art: A Historical Survey*. New York: Ronald Press Co., 1966.

Hartmann, Sadakichi, *A History of American Art*. Massachusetts: L. C. Page & Co., 1932.

Howat, John K., et al, *The Hudson River and Its Painters*. New York: The Viking Press, 1972.

Inness, George Jr., *Life, Art and Letters of George Inness*. New York: Plenum Publishing Corp., 1917.

Ireland, LeRoy, *The Works of George Inness: An Illustrated Catalogue Raisonné*. Austin University of Texas Press, 1965.

Larkin, Oliver W., *Art and Life in America*. New York: Holt, Rinehart & Winston, Inc., 1960.

Lynes, Russell, *Art-Makers of Nineteenth Century America*. New York: Atheneum Publishers, 1970.

McCausland, Elizabeth, *George Inness: An American Landscape Painter*. Massachusetts: Press of the Pond-Ekberg Company, 1946.

McLanathan, Richard, *American Tradition in the Arts*. New York: Harcourt, Brace & World, 1970.

Mendelowitz, Daniel M., *History of American Art*. 2d ed. New York: Holt, Rinehart & Winston, 1970.

Novak, Barbara, *American Painting of the Nineteenth Century*. New York: Praeger Publishers, Inc., 1969.

Prown, Jules D., *American Painting: From Its Beginning to the Armory Show*. New York: Skira Art Books, 1970.

Richardson, Edgar P., *Painting in America: From 1502 to the Present*. New York: Thomas Y. Crowell Co., 1965.

Saint-Gaudens, Homer, *The Artist and His Times*. New York: Dodd, Mead & Co., 1941.

"It is of the greatest importance for a painter always to have his mind on nature, as the star by which he is to steer to excellence in his art."

Thomas Cole

"The true artist must perforce go from time to time to the elemental big forms—Sky, Sea, Mountain, Plain—and those things pertaining thereto, to sort of re-true himself up, to recharge the battery. For these big forms have everything."

John Marin

In 1835, a foreign critic of American civilization, Alexis de Tocqueville, asserted that, however gifted Yankees might be in other areas, they were not endowed with creativity in the plastic arts. In *Demoeracy in America,* he charged that the American preferred the useful to the beautiful, that he refused to accept anything not immediately understandable, and that he was materialistic, pragmatic, extroverted, naively optimistic. The French writer further maintained that Americans were "too preoccupied with admiring their own conquest of nature to take notice of the natural beauties of their own country."

De Tocqueville was probably unaware that, in the very year that his book was published, an *Essay on American Scenery* appeared in Boston. Its author Thomas Cole was born in England but came to the United States when he was still in his teens, and he fully identified with America and the Americans. In this treatise, Cole, who was to be America's outstanding landscape painter in the first half of the nineteenth century, wrote: "The most distinctive and perhaps the most impressive, characteristic of American scenery is its wildness." While in Europe much landscape had been urbanized, in America nature was still dominant, "and the mind is cast into the contemplation of eternal things."

In Europe, the philosopher Jean-Jacques Rousseau had laid the foundations of modern nature-worship, and his belief that true happiness could be found only in the state of nature spread to the New World. Being a Swiss, Rousseau admired most the majesty of the Alps, and he bequeathed to his disciples on either side of the Atlantic, in literature as well as in the visual arts, his fascination with wild torrents, fear-inspiring precipices, virgin forests. As young men, Cole, and later Inness, must have read the novels of James Fenimore Cooper, who had opened the eyes of his compatriots to the "wonders of the woods": that is, the native forests. Indeed, everywhere in the Western World, literary men preceded the painters as appreciaters of unspoiled nature (although Dr. Johnson protested that he preferred London's Fleet Street—the hub of journalism—to any rural spot).

Love of nature was not always a phenomenon to be taken for granted, however. For thousands of years, nature was dreaded as a potential enemy, and men crossed the distances between cities in a hurry, so as not to become victims of the dangers lurking in the uninhabited spaces. In Western art, depictions of landscape date from antiquity, but this "landscape of symbols" or "landscape of fantasy" served mainly as a background for religious, mythological, allegorical, or historical compositions. Although there are exceptions—the "first golden age of European landscape painting" in Rembrandt's Holland springs to mind—on the whole, these "noble" figure subjects dominated art.

Thomas Gainsborough made a living by portraiture, though he would have preferred to "walk off to some sweet village, where I can paint landskips." In England as late as 1829, John Constable, one of the foremost landscapists in all history, was told by the president of the Royal Academy that he should consider himself fortunate to have been elected to it, as there were "history" painters of great merit on the list of candidates.

In France, prejudice against landscape painting continued to linger. "For the erudite artist landscape was inferior not only in quality, but in content; among other things, it was less morally edifying," (Albert Boime, in *The Academy and French Painting in the Nineteenth Century*). Significantly, neoclassicist Jacques-Louis David left us only one landscape. This one, his *View of the Luxembourg Gardens,* was, ironically enough, what he saw from the cell in which he was temporarily incarcerated during

the Revolution. His disciple Jean-Auguste-Dominique Ingres, another master of figurative painting, bequeathed to us no more than three small oils on landscape themes; his numerous landscape drawings were never publicly exhibited in his lifetime.

Curiously, Cole never saw—only heard of and dreamt of—America's "wildness." In fact, his finest work, *The Oxbow* (in The Metropolitan Museum of Art, New York), completed soon after the publication of his *Essay on American Scenery,* was inspired by a gentle section of the Connecticut River. This panoramic view undoubtedly served as a model for Inness' later renditions of the equally pleasant Delaware River valley. *The Oxbow* is now more widely admired than Cole's large pictures with historical and allegorical allusions. Executed with a marvelous sense of space, and infused with a tender lyrical sentiment, it surely would have received international acclaim had it been painted by a Frenchman and in France.

The same might be said of Inness' *The Lackawanna Valley* (Plate 2), *On the Delaware* (Plate 4), and *Peace and Plenty* (Plate 7), all of which are indebted to the earlier picture by Cole. George Inness (1825–1894) was even more enthusiastically given to "the contemplation of eternal things"—sky and clouds, water and earth, meadows and trees—than the older artist, who founded what became known as the Hudson River School. In fact, Inness spent most of his time sketching the vistas of his native land and, in the seclusion of his atelier, using these small preliminary studies in the preparation of hundreds of oils, some of which are quite large. He sojourned abroad in Italy, France, and England five times during his long life. But it was chiefly the Adirondacks, the Berkshires, the Catskills, and—above all—the rural peacefulness of villages in Massachusetts, on the Hudson River, or in New Jersey, that inspired the creation of probably a much larger number of paintings than the 1,541 credited to him by the indefatigable LeRoy Ireland.

Inness was luckier than the artists who preceded him, most of whom would have agreed with de Tocqueville's characterization of Americans as people with an underdeveloped esthetic sense. Inness was still at the start of his career when the romantic painter John Vanderlyn died wretchedly as a pauper, after enduring much indifference, if not outright hostility, during his long career. In the years just prior to the outbreak of the Civil War, affluent citizens were beginning to develop a real interest in acquiring works of art instead of confining themselves to commissioning family portraits. There were, at last, places such as the premises of the American Art Union and the National Academy of Design, where an artist could display his pictures. In Boston, New York, and Philadelphia, there were dealers willing to relieve a man as impetuous, irascible, and devoid of social graces as Inness of the task of selling his products to a still very skeptical and esthetically untrained clientele. And there were critics ready to look earnestly at the offerings of younger contemporaries (the most capable, James Jackson Jarves, even praised the still-youthful Inness as "the Byron of our landscapists").

George Inness came from a family whose members had not even the most fleeting contact with art. He was born on a farm—two and a half miles inland from Newburgh on the Hudson—because it was there that his father, a well-to-do grocer, had temporarily retired for reasons of health. Soon after George's birth, the family returned to New York City, and John William Inness went back to his business. When George was four, the family moved to Newark, New Jersey, which was then nothing like the huge city

it is today. It was at Newark that George received his general education, a rather elementary and even fragmentary one.

It is most surprising that an artist like Inness should emerge from a milieu in which nobody was much interested in anything but business. There is no explanation for it, except the one offered by the artist's son, George Inness, Jr., who followed in his father's footsteps by becoming a painter but is now remembered chiefly as the elder Inness' biographer. He tells us that, even when young, his father was "different" from other boys, sensitive, and of delicate health:

"He was a dreamer, an idealist from earliest childhood, and lived much in a world of his own imaginings . . . his desires first began to crystallize when, as a very little chap, he saw a man painting a picture out in a field. Immediately a responsive chord was struck, and his own nebulous groping for self-expression became at once a concrete idea. Then and there he made up his mind that when he grew up he would be a painter . . . he thought it the most wonderful thing in the world to make with paint the things that he saw around him, clouds, trees, sunsets, and storms. . . ."

Trying to turn George into a businessman, his father bought him a grocery store in which he installed the teenager as manager. But George insisted that he wanted to become an artist. Reluctantly, John William Inness allowed him to take some lessons in painting from an itinerant artist named John Jesse Barker, about whom very little is known, and later placed him as an apprentice with a firm of engravers in New York City (the same trade was learned by two older artists, Asher Brown Durand and John Frederick Kensett, who became prominent members of the Hudson River School). Later, Inness was to make very little use of the skills he had acquired in the two years he was with the firm. Nor did the painting of Régis François Gignaux, a French artist who had come to New York and with whom Inness studied for a year, make a strong impact upon his own development. He could have enrolled at New York's National Academy of Design, but classes were held in the evening and his poor health ruled out his attending. While Inness, Jr. never mentions his father's sickness by name, other biographers describe it as epilepsy. This troublesome illness, though it had reduced his professional training to a bare minimum and drastically limited his education, did not prevent him from leading what is called a normal life. He was only eighteen when he married; his bride died a few months after the wedding. Some years later he remarried, and his wife bore him six children. While reasons of health may have caused him to avoid residence in large cities and strenuous social activities as much as possible, he did travel in Europe (as stated above), he saw much of the United States, and he visited Mexico City and Cuba.

Contemporary portraits (both paintings and photographs) show him to have been a small, lean man with an ascetic face framed by a straggly beard; but his fragile health did not prevent him from accumulating an enormous body of work. Nor can a viewer of this work surmise that, quite apart from his physical illness, its maker was very moody and suffered from frequent fits of despair. Calm and peacefulness prevail in nearly all of Inness' paintings. *The Mill,* said to have been painted when George was only sixteen and known only through faded photgraphs, shows part of a mill and a boy on a wooden footbridge that spans water flowing over a dam. It is as tranquil and serene as what is believed to be Inness' last study from nature, *Hills of Scotland,* done fifty-three years later. While the composition and technique of *The Mill* are, of course, unsophisticated, the two oils have nevertheless much in common. There is something

untroubled and even soothing about them, a gentleness of spirit, a quality of timelessness, and an utter lack of the flamboyant or grandiose.

Still, the way is long from the pictures Inness produced in his youth—such as *Evening* and *Sunset,* which were shown at a National Academy of Design group exhibition in 1844 and mark his entry into the art scene—to the final works that have "Inness" written upon every square inch. For, while his character may not have undergone a drastic change, his manner of painting did. In his first decade as a painter, at least, he was mildly influenced by the Hudson River School artists, among whom he most admired Cole—who, in Inness' own words, had a "lofty striving," even if he "did not technically realize that for which he reached"—and Durand, who had "a more intimate feeling of nature." But, although Inness is often classified with these masters, it is an error. He lacked Cole's vivid imagination, and his approach was more painterly than that of the linearist Durand. And Inness actually had little in common with the younger artists of the Hudson River group, such as Frederic Edwin Church and Albert Bierstadt, who belonged to his own generation. Their pictures, which were often enormous in size, emphasized the awe-inspiring grandeur of Far Western landscapes in a far more romantic manner than Inness was ever capable of.

Of course, without the Hudson River School, no native American art, more or less independent of European models, might have come into being. Philip Hone, a rare combination of auctioneer, art patron, and mayor of New York City, was certainly filled with patriotic pride when he praised Cole's landscapes as bound to delight Americans devoted to their own country, though the manner and subjects might not please collectors accustomed to Italian skies and English park scenery.

In many ways, Inness stood alone in the art world of nineteenth-century America. He shunned genre painting: pictures of familiar, everyday life in the big cities, in the villages, and on the farm; Redskins and Palefaces locked in ferocious battles; buffalo hunting; and the hazardous travels of pioneers in covered wagons. He has left us no portraits, no paintings of people in interiors, no works on literary or religious subjects. The title "father of the American landscape" fits him better than it does anyone else. But he preferred what he called "civilized landscape"—places which suggest the nearness of man as a farmer and builder—to the entirely untamed wilderness.

In his pictures, human presence is more often indicated by cornfields, grazing grounds, and rural habitations than by the introduction of actual people. As a rule, there is one figure looking away from the picture plane into the landscape. Or there may be a pair like the one walking through a meadow above the village of Etretat (Plate 17) or contemplating Niagara Falls (Plate 24). A picture like *Lake Albano* (Plate 10), whose foreground is filled with a great many holiday-makers, is a rarity, especially since the figures in it are well-defined. Most of Inness' peasants or strollers are inconspicuous combinations of small color spots, brushed in as chromatic focal points, or to indicate the scale. In a few pictures of the early 1880's, "larger" figures turn up, along with renderings of domestic animals. But the artist probably knew that the figure was not his forte—perhaps because of his lack of rigid academic training—and, in the final decade of his career, the figure is again reduced to small color spots.

As the captions in this book reflect, Inness changed his style three or four times, though he never abandoned or even subdued his own personality in response to outside influences, whether artistic, reli-

gious, or political. The impact the Old Masters had upon some of his early compositions is obvious (he knew these masterworks only from engravings, which he carried with him even while sketching in the open air). His first stay in Europe (1850–1852) acquainted him with works of the Barbizon School, a name given to a very loose association of painters who abandoned Paris for the little village of Barbizon at the entrance to the forest of Fontainebleau. These men, who glorified the bucolic scene in defiance of classicism and all it stood for, opened the way for the *plein-air* painting that was practiced subsequently by the Impressionists.

"As landscape-painters I consider Rousseau, Daubigny, and Corot among the very best," Inness once told his son, though he had some reservations about the work of all of these Barbizon pioneers. Unlike Corot, who often peopled his landscapes with biblical or mythological figures, Inness avoided story-telling content. Nevertheless, the two—who never met—had much in common. Both sketched in nature's open spaces, but afterward reconstructed nature in terms of their own imagination, in the solitude of the studio. As Corot put it: "I invite Nature to spend some days with me in my studio and it is then that I let my fancy run free."

Both, with perfect balance and an unerring feeling for values, transposed factual data of reality into the domain of art. What one biographer said of Corot's poetic crystallization of nature—that what the master sought to render was "not so much Nature herself as the love he bore her"—might be applied to Inness as well.

Inness was also under the spell of Constable, who saw the outward forms of nature "imbued with a spiritual significance" and who firmly believed that the artist could "extract from the physical world around him an element of moral truth," and of Turner, who painted in accordance with the dictum, "I do not imitate nature, I improve on it."

Yet Inness was not an eclectic who applied the inventions of other, sometimes greater men to cover up his own shortcomings. Whatever he took from others he immediately adjusted and changed to serve his own needs. Whatever the Delaware River scenes may owe to *The Oxbow,* they are unmistakably Inness rather than Cole. By the same token, his forest scenes are not to be confused with those of Corot. For one thing, they are sturdier, earthier, than the Frenchman's dreamlike atmospheric effects. Inness never allowed scenes to dissolve into silvery or golden hazes. While no match for Corot in many ways, Inness never allowed sentiment to deteriorate into mawkishness, as the Frenchman sometimes did in his final years.

In his own best work, Inness proved to what extent an artist can conform to reality without becoming a mindless photographer, and, on the other hand, how far he can go in the direction of simplification without losing significance. He could be lyrical without being lachrymose. Instinctively, he avoided slickness. He did not show off the manual dexterity he had acquired in decades of unceasing practice. His finest work is bound to remind us of Wordsworth's definition of poetry as emotion recollected in tranquillity.

If we concentrate on Inness' strongest pictures, a nostalgic desire moves us to seek out the villages in New York, Massachusetts, and New Jersey which inspired most of his paintings, or the Roman Campagna, Perugia, and other places in Europe. Actually, however, even the nineteenth-century photos of

his lost works reveal that his pictures are less topographical than so many of the landscapes painted by the Impressionists in the *belle époque*. Upon close analysis, a landscape by Inness will prove to be a rendezvous with the artist's dream, rather than with any particular piece of architecture, range of hills, or expanse of water.

And Inness, who had a blind spot for the indubitable achievements of the Impressionists, was not a Realist either. Despite his indebtedness to so many masters, he was *sui generis*—he cannot be pigeonholed. Though he held a number of strong ideas on esthetics and on the art of painting and was always glad to expound them to anyone willing to listen, his theories, fortunately, did not affect his painting. In this respect, he was better off than Courbet, who often went astray by mechanically painting what he found ready-made in "reality," in an effort to put into practice his own rigid theory of *réalisme* (though Courbet was marvelous whenever the artist gained the upper hand over the theoretician). Indeed, the poet-critic Charles Baudelaire declared Realism to be a "vague and obscure" word. Painting from the Early Renaissance to the Impressionists is, ironically, characterized by the application of "realist" principles in theory and by their repudiation in practice. Giorgio Vasari, an astute man and an artist himself, admired the *Mona Lisa* for being an "exact copy of nature," whereas most of us are inclined to praise it for its nonrealist, lyric aspects. Inness declared that Courbet's "power" was "in a strong poetic sense," yet his French colleague would in all likelihood have resented this sincere and astute compliment.

Inness' condemnations, as well as his approvals, of fellow artists need not be taken too seriously. But his inability to do full justice to Impressionism, as well as to a somewhat earlier phenomenon, the Barbizon School, must not surprise us. As a practicing artist whose work was not generally appreciated and bought until he was about fifty, and who lived as a sort of recluse, many miles distant from the art centers, during his years of fame, Inness could not help being one-sided and even biased when journalists did come to interview him. "To the great painter, there is only one manner of painting—that which he himself employs," Oscar Wilde quipped. There is no doubt that Inness considered himself a great painter and there were many who agreed with him.

Yet, for an understanding of what Inness himself was after, his statements are of immense value. His disciple Elliot Daingerfield recalled how eager he was to explain one of his pet theories: "During the delivery of this exegesis his declamation was flaming, very fierce, and assured. His eyes sparkled, and his mane-like hair was tossed about, and hands were as vigorously in motion as possible, the whole manner commanding attention."

Inness' credo seems to be contained in these sentences: "The true purpose of the painter is simply to reproduce in other minds the impression which a scene has made upon him. A work of art is not to instruct, not to edify, but to awaken an emotion. Its real greatness consists in the quality and the force of this emotion."

By "impression" he means the excitement created by the contemplation of a scene. Repudiating his early manner—when he naively tried to paint accurately and meticulously every leaf, every stone—he explained the more "abstract" approach he had adopted in the prime of life: "Details in the picture must be elaborated only fully enough to produce the impression that the artist wishes to reproduce. When more than this is done, the impression is weakened or lost, and we see simply an array of external things which

may be very cleverly painted, and may look very real, but which do not make an artistic painting. The effort and the difficulty of an artist is to combine the two, namely, to make the thought clear and to preserve the unity of impression."

Inness rejected with disgust the thousands of smooth, glossy pictures of the kind known as calendar art that proliferated in the Brown Decades after the Civil War, though they were often created by men with celebrated names: "The true artist loves only that work in which the evident intention has been to attain the truth, and such work is not easily brought to a fine polish. What he hates is that which has evidently been painted for a market. The sleekness of which we see so much in pictures is a result of spiritual inertia, and is his detestation."

Asked about the goals of art, he replied: "The true use of art is, first, to cultivate the artist's own spiritual nature, and secondly, to enter as a factor in general civilization. . . . The highest art is where there has been most perfectly breathed the sentiment of humanity."

Sentences like these may sound strange in the 1970's, that have witnessed the dehumanization, the despiritualization, of life, not only in the realms of commerce and technology, but in that of the arts as well. But it might be profitable to ponder their wisdom. While Inness' condemnation of Monet's offerings as "humbug" again proved Wilde right in his caustic remarks on the artist in the role of critic, one can well understand why Inness was opposed to the Impressionists' entire philosophy, as well as to their technique (the "rainbow palette," the broken colors). While he held fast to the painter's traditional concern with mass and space, the Impressionists sacrificed plasticity of form to capture fleeting effects of light. Monet, in particular, pushed his technique so far that he dissolved everything solid into vibrant impressions, until all feeling that something was made of wood or stone was lost.

Inness, by contrast, rendered nature as much from feeling and knowledge as from dispassionate sight. Distrusting the fugitive effects that were Monet's specialty, he recreated nature in solidly constructed architectural forms (even where hazes or mists blur and blunt the outlines, as is the case in many a picture he produced in his old age). Not satisfied to be, like Monet, "only an eye," he refused to submit to the tyranny of nature. Hence, his work is characterized by a passion for order and organization, by a thirst for design that is just the opposite of the extreme, haphazard, verisimilitude which mars, in particular, the products of the Impressionists' mindless imitators.

To Inness, the artist's task was not to be a camera, but to create order out of chaos and to blend the "real" with the "unreal"—in other words, not to ignore what Kandinsky, an artist with totally different esthetic tenets, was many years later to call the "spiritual" in art. He sought—at times successfully, at other times not—the truth that lay beyond reality. The word "truth" appears astonishingly often in Inness' utterances, as in this one, justifying the numerous transformations his art had undergone: "I have changed from the time I commenced because I have never completed my art and, as I do not care about being a cake, I shall remain dough, subject to any impression which I am satisfied comes from the region of truth."

The artist might have said this truth flowed to him from God—who had opened the eyes of his spirit—echoing the eighteenth-century mystic Emanuel Swedenborg, whose philosophy began to appeal to Inness after his attractions to Baptism and then Methodism had waned. To see with the eyes of the

spirit, Inness did not have to spend many hours in front of the motif or to begin and finish the picture in the open air. He made quick sketches in the fields and wood and, more importantly, he retained a mental image of what he saw. One acquaintance recalled: ". . . his memory was such a store-house of places and things which he had studied in early days that he drew on it and painted a truth laid away in his memory —and an actual scene."

Once Inness even went so far as to assert, "The subject is nothing," as he casually changed a sea-scape into a landscape. Yet this bold statement must not mislead us into thinking that he indulged in speculations paralleling those of twentieth-century abstract painters. Whenever he used his brush—and his thumb—he gave us renderings of land, sea, and sky, from placid village scenes to stormy oceans, and from the northern vegetation of New England to the almost tropical flora of the Gulf of Mexico coast. There is a good deal of repetition, but there is no monotony, as, from the same subject matter, Inness could always derive a different visual experience. There are, of course, subjects that occur only once, like *The Lackawanna Valley* (Plate 2), which was a commissioned piece, or *The Pines and the Olives* (Plate 15). On the whole, however, Inness' *oeuvre* consists of variations on a limited number of themes, often with stronger emphasis on the power of expression than on the precision of topographical reality.

Inness never painted portraits and—this is rare in an artist—did not leave us a single self-portrait. Only once did he paint a mythological scene, *Diana Surprised by Actaeon,* which is now lost. He deliberately confined himself to a few motifs: "rivers, streams, the rippling brook, the hillside, the sky, the clouds," to use his own listing. During half a century, he occupied himself with moisture-laden air, rain effects, clouds clearing after the rain, rainbows, mists, vapors, fogs, smoke, and hazes. He loved the colors of dawns, dusks, twilights, moonlights, and sunbursts, the colors of all seasons and of all hours of the day—without, however, the Impressionists' eagerness to capture the most evanescent atmospheric and optical effects. In the pictures by Monet and his associates, vibrations of light imply more motion, more action; in Inness' works, the air is still and there is a hushed feeling of silence or, at most, of a drowsy hum of nature lost in dreams. A storm may be about to break out any minute or have just abated; but one never finds the wind-tossed branches, the quivering trees, that were a favorite theme of the Expressionists.

Inness did not always enjoy what is called a good press. But there were more favorable than negative reviews. When he was only thirty-five, he was hailed by a critic in New York as "a man of unquestionable genius" and as "one of the finest and most poetical interpreters of Nature in her quiet mood." There were many other enthusiastic statements. Among his admirers were the celebrated preacher and lecturer Henry Ward Beecher and the noted writer James Jackson Jarves. But for a long time sales were rare and the prices low. In his biography of his father, George Inness, Jr. recalls periods of considerable difficulties for the family.

The situation improved, however, after Inness' return from his fourth trip to Europe (1875), and for the last two decades of his life the artist had his own comfortable home and was free of all economic worries. In fact, at a time when rich Americans filled their mansions with expensive works by Old Masters, or with works by the fashionable artists of France, Inness was the only American whose paintings were eagerly acquired by owners of works by Florentines, Venetians, and the now fashionable Corot.

Accompanied by his wife, he sailed for Europe again in 1894, visited France and Germany, and then moved on to Scotland, where he occupied himself with sketching the mountains. On August 3rd, the couple was at the small Scottish town of the Bridge-of-Allan. As the son reports, the artist walked out to watch the sunset: "Just as the big red ball went down below the horizon he threw his hands into the air and exclaimed, 'My God! oh, how beautiful!' and fell stricken to the ground."

Aware that he was about to die, he asked to be taken to his wife, in whose arms he drew his last breath. His body was brought back from Scotland and placed in state in the Academy of Design, of which Inness had been a member since 1869. The funeral was held there on August 23rd. The U.S. flag flew at half-mast on the building. Inness' earthly remains were placed in a casket of silver and velvet: on a pedestal at its foot stood a bronze bust of the artist. The grand stairway was draped in black. The large crowd attending the services heard the minister say: "I believe, with many artists, that his fame will be a lasting one, and has not yet by any means reached its limit. . . . He was an intense man. He was a genuine man. He was a true genius."

Though he was modest in behavior and not interested in any positions of honor during his life-time, Inness would have fully agreed with this eulogist, and also with the writer for the Boston *Transcript* who called his landscapes "the best painted in our time and country, in many instances the best painted in any time or country."

The praise that was bestowed upon him in his final years—and in the decade or so after his demise—may seem exaggerated to a generation taught to prefer the more hectic landscape themes of the Post-Impressionists, Fauves, and Expressionists, whose colors are hotter, bolder, and more arbitrary than even the brightest Inness ever used. It is easy to underestimate Inness, as has been done repeatedly by those seeking more fireworks, more patent virtuosity, more action, more external movement. Though his pictures hung in a great many public collections, such as The Metropolitan Museum of Art, the Art Institute of Chicago and the Museum of Fine Arts in Boston, he was rarely mentioned for a long period. Until recently, for instance, the only substantial book available about him was the one authored by his son, published in 1917, and soon out of print.

His "return" can be linked with the recent upgrading of the masters who were the idols of his youth; in 1962 a comprehensive exhibition, *Barbizon Revisited,* was mounted by four American museums. Also in the 1960's, more attention was paid to American art of the previous century and, in general, to all things American (but without the chauvinism of earlier Regionalists and America-firsters). Significantly, in 1965, a large volume, *The Works of George Inness,* was issued by the University of Texas Press. Its author LeRoy Ireland had spent virtually his entire life gathering material for this most informative illustrated *catalogue raisonné.* Six years later, Nicolai Cikovsky, Jr. published his book on Inness, based on an earlier Ph.D. dissertation prepared at Harvard University. In the mammoth show, *19th Century America: Paintings and Sculpture,* a centennial exhibition of The Metropolitan Museum of Art (1970), Inness was represented by *The Lackawanna Valley, The Pines and the Olives,* and, on loan from Buffalo's Albright-Knox Art Gallery, *The Coming Storm.* In the 1960's, memorial shows were held by public institutions at Oshkosh, Wisconsin; Montclair, New Jersey; and Austin, Texas.

However, the new interest in Inness was not prompted—or at least solely influenced—by the recent

rediscovery of America's artistic past. It was also helped by the current trend away from nonrepresentational art and by the revival of what, for lack of a more appropriate term, has been called realist art. A third factor was the nostalgia for an America that is no more, that survives only in the works of the Hudson River School artists, in those of Inness, and, after him, the American Impressionists.

For Inness lived in—and recorded—a period when the American countryside was still relatively untouched by technology and industry (although the stumps of felled trees in the foreground of *The Lackawanna Valley* indicate that a start had been made). New York City had its share of slums and bleak factories when Inness had his studio there, but he did not have to travel long distances to find his beloved motifs in the still rather unspoiled nature just outside the city limits. During his lifetime, it was not yet imperative for conservationists, environmentalists, or concerned citizens to band together to stem the tide of pollution. And the paintings of artists like Inness now preserve that image of green, pre-industrial America.

Inness' determination and endurance in that effort give eloquent testimony to man's indomitable spirit. Frail, sickly, and for a long time without adequate funds, he never gave up the struggle for the achievement of the best he was capable of. Growing up in a milieu in which the visual arts played no role, and mostly for reasons of health denied a thorough training, he not only took to painting but even made a stunning success of it. Religion may have played a role as a comforter, yet it was largely the contemplation of nature that soothed and nourished his troubled soul. Mental health, his story seems to proclaim, is best safeguarded by bonds with unravaged nature. The artist's work not only offers us the joy that comes from viewing beauty, but also serves as an important reminder that nature provides a bottomless source of strength and spiritual vitality.

Color Plates

Plate 1
A BIT OF THE ROMAN AQUEDUCT
Oil on canvas
39″ x 53¼″
1852
The High Museum of Art, Atlanta, Georgia
Gift of the Members Guild, 1969

At the end of 1850, Inness and his new bride sailed for Europe. They spent fifteen months in Italy, first in Florence and then in Rome. The countryside around the Eternal City—*la Campagna di Roma*—enchanted the artist and inspired many paintings, of which this is one. He was not the first American artist to fall under the spell of the Central Italian landscape. Washington Allston and Thomas Cole, among others before him, had wandered excitedly through the low country around Rome that was studded with ancient ruins, inhabited by peasants and their cattle, and covered with lush Mediterranean vegetation. The writer Washington Irving recalled his journeys there in the company of the painter Allston: "the blandness of the air, the serenity of the sky, the transparent purity of the atmosphere and the nameless charm which hangs about an Italian landscape."

This painting seems to have been influenced in composition, in the emphasis on details, and in the smoothness of the picture surface by several Old Masters whose prints Inness must have seen. The distinctly and carefully formed trees are reminiscent of such masters of precise observation as Meindert Hobbema and Gaspard Poussin (Gaspard Dughet, the brother-in-law and student of Nicolas Poussin, who assumed his teacher's well-known name), while the atmospheric softness recalls Claude Lorrain. Yet, while the painting may only suggest the sheer topographical aspects, Inness superbly captured the intense sunlight, the untroubled sky, the peacefulness of the wooded spot. The little figures tell no story, point no moral. This is a picture combining classical with romantic elements. It exudes a nostalgia for undisturbed nature. Exhibited in 1853 at New York's National Academy of Design, it is one of many on Italian themes that Inness made in the early 1850's.

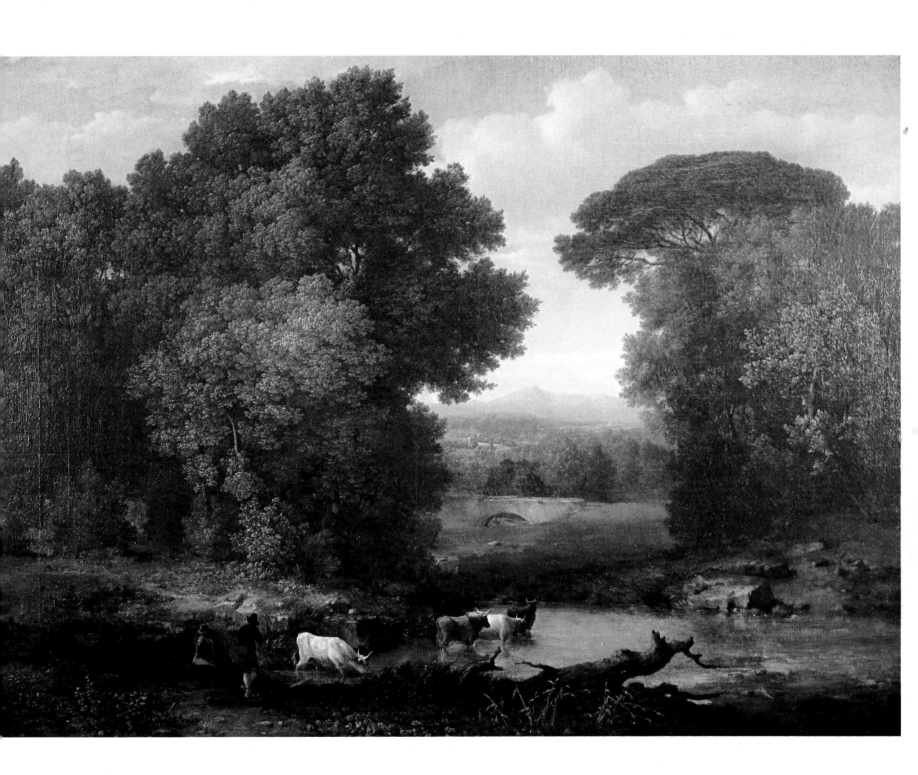

Plate 2
THE LACKAWANNA VALLEY
Oil on canvas
33⅞″ x 50¼″
1855
National Gallery of Art, Washington, D.C.
Gift of Mrs. Huttleston Rogers, 1945

This picture is also listed as *The First Roundhouse of the D.L. & W.R.R. at Scranton.* The shorter and better-known title refers to the river that rises in northeastern Pennsylvania, passes several industrial cities and, flowing south-southwest, joins the Susquehanna. The longer title commemorates the painting's genesis. It was commissioned by the first president of the then new Delaware, Lackawanna and Western Railroad. The artist traveled by stagecoach to make sketches on the spot. He was paid $75 for the finished picture. Apparently, the owner did not care for it, for when Inness visited Mexico City in the mid-eighties he picked it up for a song in an old curiosity shop.

Though it was little more than an advertisement for a railroad and therefore a "potboiler" in origin, it is a remarkably beautiful picture. As Inness himself once said of it, "there is considerable power of painting in it, and the distance is excellent." In its broad, panoramic quality, it is not inferior to Thomas Cole's *The Oxbow* (The Metropolitan Museum of Art, New York), painted a decade earlier and depicting the Connecticut River in Massachusetts. To please his patron, the artist carefully painted the roundhouse—the circular building for housing and switching locomotives—as well as the repair shop, the train, and the tracks. But he obviously enjoyed rendering the sweep of green fields and the hazy atmosphere more. The freshness of light, the breadth of handling, the informality of arrangement almost make one forget that little is left now of the lyrical poetry Inness encountered in that valley as a young man of thirty.

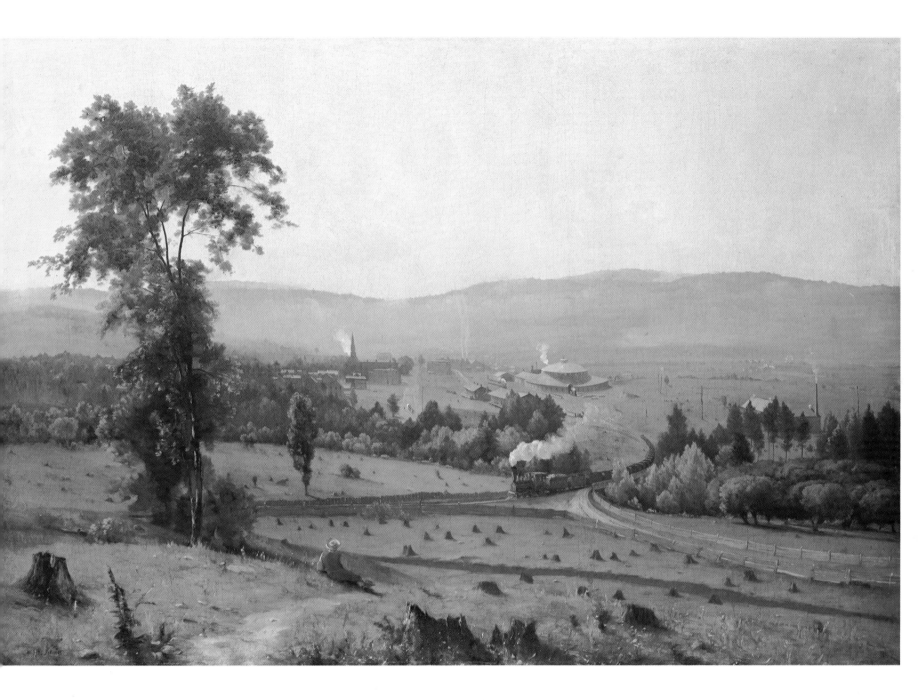

Plate 3
ST. PETER'S, ROME
Oil on canvas
30" x 40"
1857
The New Britain Museum of American Art, New Britain, Connecticut
Charles F. Smith Fund

St. Peter's, Rome is one of the fruits of Inness' second European trip (1854–1855). Rome had long been the favorite of *vedutisti* (view painters) who specialized in topographical renderings of sites. The two most famous were Giovanni Paolo Pannini and the engraver Giovanni Battista Piranesi. There was also Camille Corot, nearly thirty years older than Inness. These were far superior to the crowd of ordinary manufacturers of pretty pictures that were sold to foreigners making the Grand Tour. We know the exact place where Inness made the sketches for this painting, which was later executed in New York City— a spot above the Arco Oscuro, a natural opening in the rocks of the Parioli hill, in the northern part of the city. The motif—looking southward across the Tiber River to the center of the city—was highly esteemed by nineteenth-century artists. On either side of the river, the still, low flats of Rome (not yet the capital of a united Italy) are dwarfed by Michelangelo's majestic dome of St. Peter's, and by the enormous bulk of the palace of the Vatican. The gardens and walls in the foreground belong to the Villa Giulia, built by Pope Julius III, *ca* 1552–1544, and now house the Museo Nazionale Etrusco.

Like so many of his colleagues, Inness was overwhelmed by the beauty and warmth of Italy, and produced here a veritable poem of light. The picture is imbued with a serenity, with an intense stillness and peacefulness, that are characteristic of nearly all of Inness' work—a quality astonishing in one known to have been in poor health most of his life, and melancholy as well as irascible. In this work as in many others, the artist successfully strove to attain an equilibrium, a balance and harmony, that he could not achieve in his dealings with people.

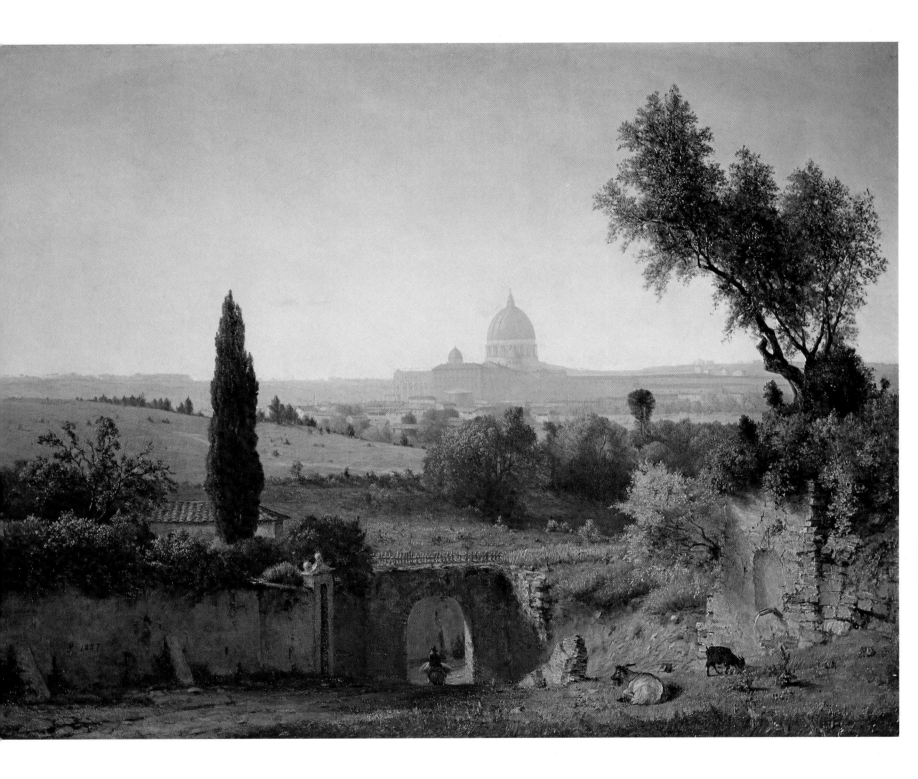

LeRoy Ireland's *catalogue raisonné* lists more than twenty works by Inness depicting the Delaware, one of the major rivers of the eastern United States flowing into the Atlantic. The most famous of these is *Delaware Water Gap* (The Metropolitan Museum of Art, New York). The locale in these twenty paintings is always more or less the same. The artist looks down from an elevation, at a point where the stream breaks through the range of hills. It is a pleasing sight: the majestic river slowly flowing through the fertile valley, with farm buildings and clumps of trees.

While bucolic charm is conjured up by the cows peacefully grazing in the foreground, the busy life of Yankee enterprise is introduced by the barges carrying goods, and by the locomotive and its train at the left. It is doubtful whether any of the Hudson River School artists—with whom Inness is often lumped together—would have cared to include such an unromantic element of modern technology. Thomas Cole praised the "sublimity of untamed wilderness and the majesty of the eternal mountains," whereas Inness declared himself for what he called the "civilized landscape." Inness' idol, the French painter Théodore Rousseau, is known to have waged a battle against the deforestation of Fontainebleau and the building of modern roads. Another member of the Barbizon School of painting, Charles-François Daubigny, complained upon arriving at a certain spot, "Everything I wanted to paint has been destroyed!" Inness, however, seems to have been unaware of, or at least unconcerned with, what was to be called "pollution."

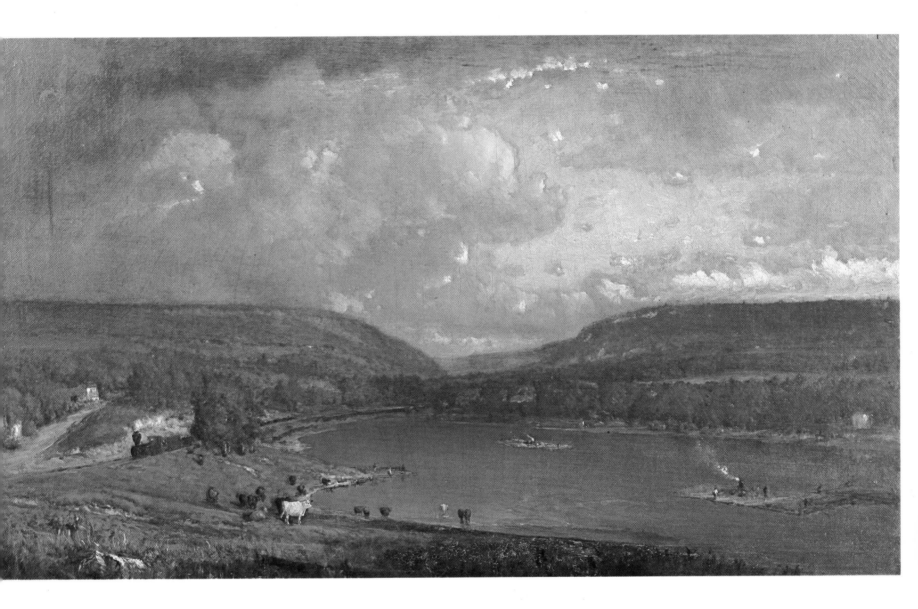

Plate 5
ROAD TO THE FARM
Oil on canvas
27" x 37"
1862
Museum of Fine Arts, Boston, Massachusetts
Gift of Robert Jordan from the Eben D. Jordan Collection

Discussing early influences at the height of his career, Inness is quoted by his biographer Elliott Dainger-field as having said of some picture, "I was thinking much of Hobbema when I painted it." We do not know which picture he was referring to, but it could very well have been *Road to the Farm*. Mein-dert Hobbema (1638–1709) was one of Holland's greatest painters of trees, and had been a pupil of Jacob van Ruisdael, who had an even deeper feeling for the unique qualities of woods and has been hailed as "the painter of the forest."

Compositions based on a country road, flanked by trees and receding into the background, appear throughout the works of Inness' half-century-long career. This picture is similar in design to Hobbema's *The Avenue of Middelharnis* (The National Gallery, London), one of the master's most frequently re-produced pictures. Just as Hobbema's paintings are devoid of the feeling of solitude and mystery that characterize his teacher's work, so Inness, unlike some of the earlier American landscapists, generally presents trees as friends—as man's companions—rather than as the overpowering rulers of the wilderness. A small picture like *Road to the Farm* is calculated to offer the city dweller an inkling of the peace of rustic life. It is cheerful, as it depicts a shepherd with his flock on a sunlit road, and the farmhouse to which he is heading. Though his main interest was the human figure to the near-exclusion of landscape, Henri Matisse would have agreed that this painting met his own goals:

"What I dream of is an art of balance, of purity and serenity devoid of troubling or depressing sub-ject matter, an art which might be for every mental worker . . . like an appeasing influence, a means of soothing the soul. . . ."

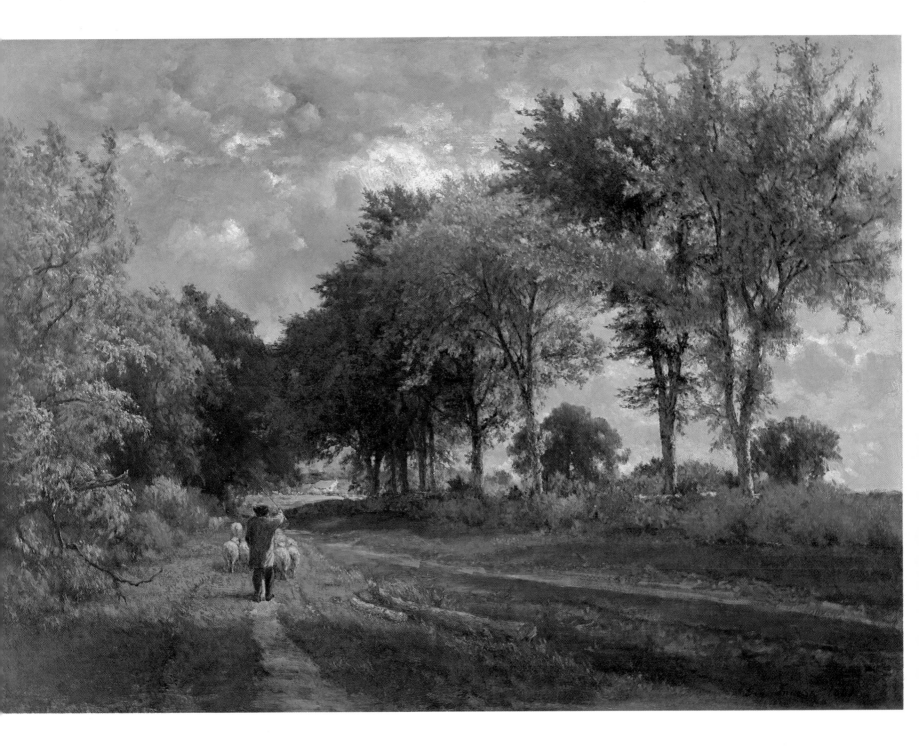

Plate 6
THE CLOSE OF DAY
Oil on canvas
26″ x 36″
1863
J. B. Speed Art Museum, Louisville, Kentucky

Many works of Inness render the very early or the very late daylight hours, when the rising or sinking sun transforms humdrum reality with its magical cloak of mystery. Several other pictures reproduced in this book—such as *Christmas Eve* (Plate 9) and *The Pines and the Olives* (Plate 15)—also make the most of the beauty of dusk. Repeatedly, the artist painted the descent of the sun below the horizon, and the reflections of the sunset sky in a river flowing through the center of the picture. In the words of Sarah Helen Power Whitman, a nineteenth-century poet, this is the hour when evening "trails her robes of gold Through the dim halls of Night."

In the painting, drama is introduced by the tall elm that rises among the rocks in the foreground. Note the superb reflection of the sky in the waters. The hill in the distance had once been an Indian gathering-point, and, bearing this fact in mind, Inness placed on the river a tiny canoe carrying the figure of an Indian. It was a bit of poetic license: by 1863, Indians were no longer roaming in the vicinity of Boston.

The picture was painted in Medfield, a suburb of Boston, where the artist and his family lived from 1860 to 1863 or 1864; he worked in an old barn converted into a studio. While the Medfield period is one of great importance in the artist's life from an artistic viewpoint, it was also "lean financially," as George Inness, Jr. remarks caustically.

32

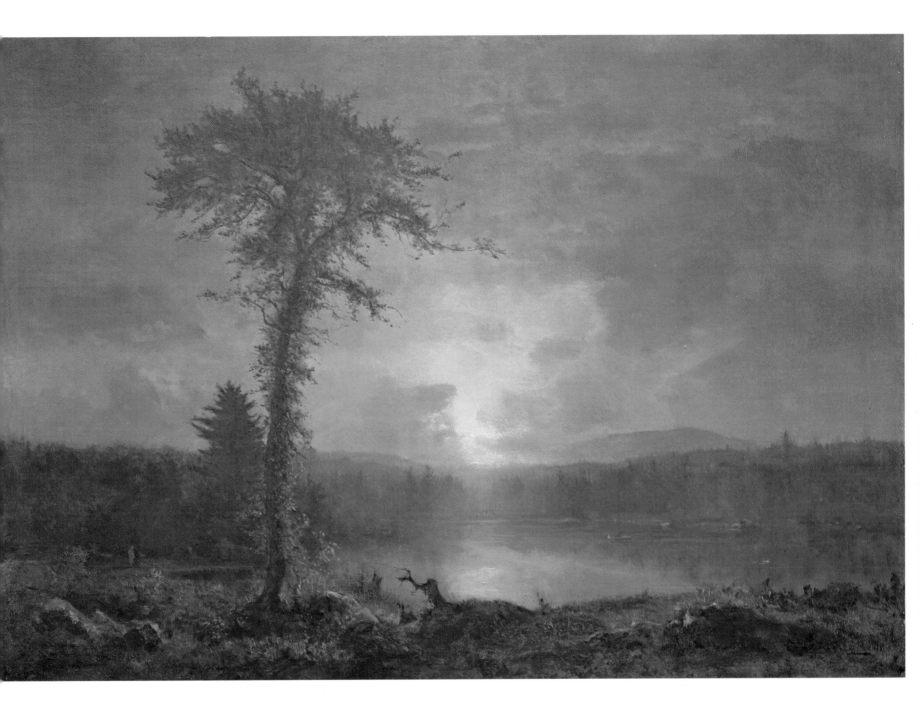

Plate 7
PEACE AND PLENTY
Oil on canvas
77⅝″ x 112⅜″
1865
The Metropolitan Museum of Art, New York, New York
Gift of George A. Hearn, 1894

This very large canvas is the most frequently reproduced and, therefore, the most widely known of all of Inness' works. It was painted in Eagleswood, New Jersey, from studies the painter had made near Medfield, Massachusetts, to celebrate the end of the Civil War. Through it, the artist tried to express his faith in the now reunited America, and his pride in the wealth and serenity of its vast lands. Post-bellum America, he seems to proclaim, should now enjoy the pleasures derived from looking at a fertile valley at harvest time, symbolizing all the calm and harmony that comes with the proclamation of peace.

Here, as in *The Lackawanna Valley* (Plate 2), a large vista is offered, from the ripe fields in the foreground to the hills beyond the valley. While this view may not be topographically "correct"—*Peace and Plenty* was composed far from the original spot, or spots, and was based on a variety of different sketches—it is as convincing as a more "realistic" landscape would be. One cannot sufficiently praise the execution of this picture, the simplicity of the means with which the artist produced a majestic pastoral of bounty. It offers another example of what Inness called a "civilized landscape," capable of conveying "human sentiment." The meretricious detail found in his early pictures is now happily absent. He had begun to see that "elaborateness in detail" did not gain him any meaning: "I could not sustain it everywhere and produce the sense of spaces and distances and with them that subjective mystery of nature with which wherever I went I was filled."

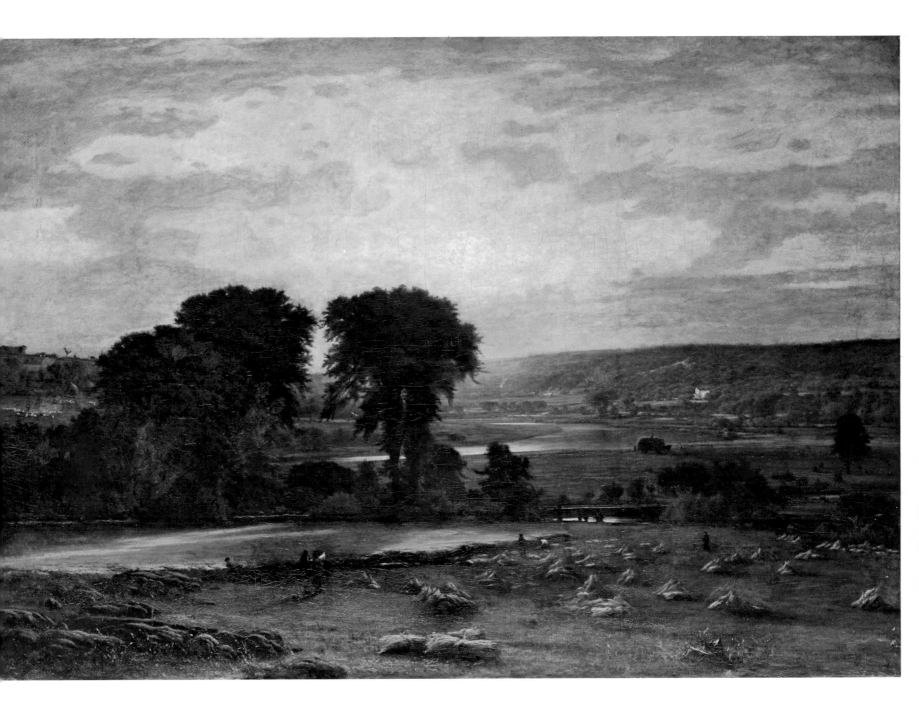

Plate 8
MOUNTAIN LANDSCAPE: THE PAINTER AT WORK
Oil on canvas
47½″ x 71¾″
ca. 1865
Berkshire Museum, Pittsfield, Massachusetts

This picture also has another title—*Leeds in the Catskills, with the Artist Sketching*—which is the title used by the owner. The Catskill Mountains, a range of the Appalachian Mountains just west of the Hudson in southeastern New York State, was and still is a wooded rolling region with deep gorges and many waterfalls, sought out for its scenery by vacationists. Here, a grand view of a mountain range, with crags and tall fir trees, is presented. A very tiny figure in this majestic setting is the painter seated before his portable easel, with a big sunshade beside him.

Once upon a time it was considered revolutionary to paint "on location." In England, John Constable and Richard Parkes Bonington were the first to paint in the open. In France, the masters of the Barbizon School worked under the open sky to catch effects of light and atmosphere not attainable in the murkiness of the atelier. Théodore Rousseau's first *plein-air* work was done in 1827 (he was then only fifteen). Camille Corot began to paint seriously outdoors in about 1822, but he did not dare to exhibit this kind of work prior to 1849. Though Inness admired Rousseau and his associates, who worked in the village of Barbizon on the edge of the Fontainebleau forest, he himself failed to close the traditional gap between the direct sketch and the finished studio painting. He was antagonistic toward the Impressionists, who worked outdoors almost exclusively. While he made small sketches in the open, he always did the major part of his work in the seclusion of his atelier.

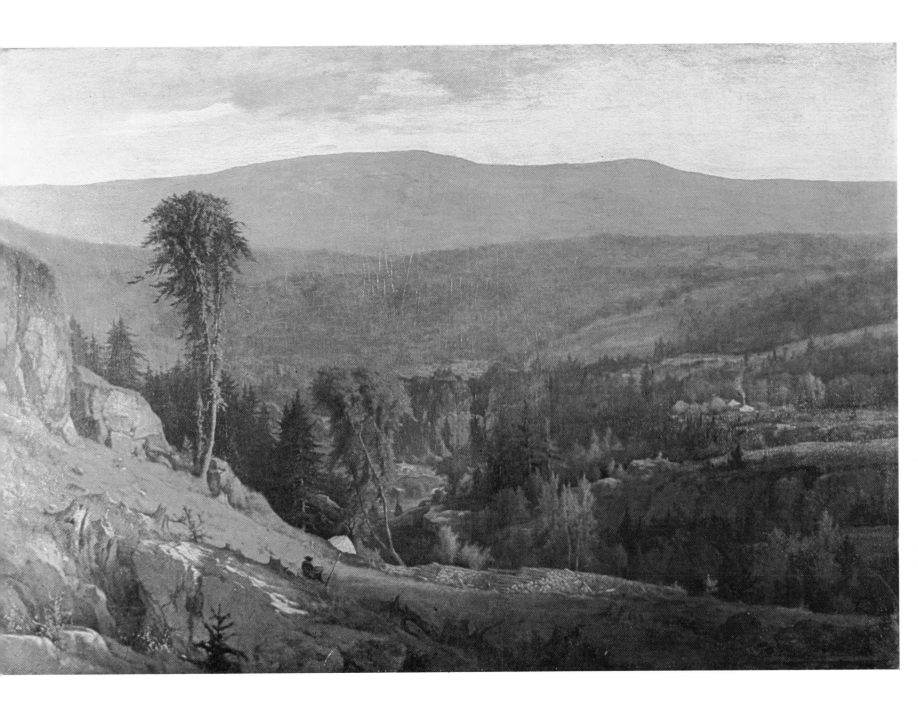

Plate 9
CHRISTMAS EVE
Oil on canvas
22" x 30"
1866
Montclair Art Museum, Montclair, New Jersey

The picture is also known as *Winter Moonlight.* It is reported that the artist gave it to his dentist, George W. Hill, in lieu of cash payment for services rendered.

There are many moonlight scenes in Inness' work (in this book, see *Moonlight,* Plate 31). An eerie mood is created here; the moon breaking through the clouds makes visible the small figure of a man who seems to be walking toward the farmhouse, where a tiny light—a little red dot in the attic—hints at another human presence. Inness often painted winter landscapes (see *Winter Morning, Montclair,* Plate 22) and imbued them with his own melancholy. While a locality like this one may have existed, one need not look for it on a map.

By now, his literal copying of nature leaf by leaf had given way to broad simplifications, to dark browns on a palette rich in sensuous appeal. From close observation of nature, Inness was moving to deep meditation—to what his biographer Elizabeth McCausland called "the private world of his own imagination." After all, there was much of a poet in him, one bent primarily on interpreting the poetry which Nature herself had to convey. Moreover, his ability to create form and depth is well-represented here.

Note how a complete stillness, a perfect equilibrium, is produced by the particular placement of the moon. If it were moved left or right of center, no such entirely satisfying solemnity and peacefulness could be accomplished. Yet, despite the centrality to which the eye is led by all diagonal lines, no feeling of monotony is created—largely because of the great variety in the different shapes.

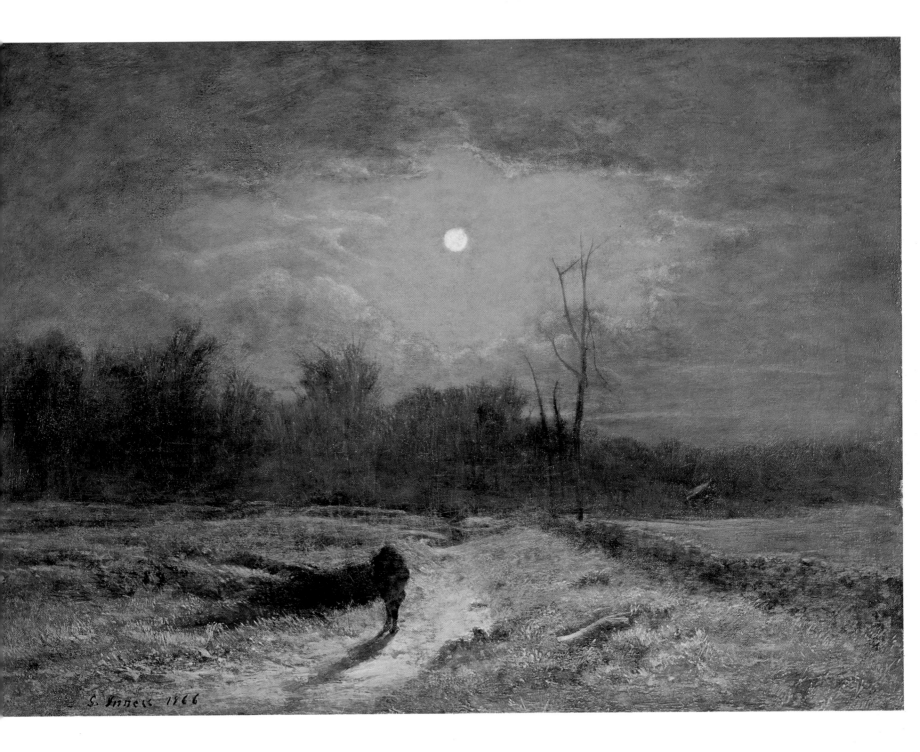

Plate 10
LAKE ALBANO, ITALY
Oil on canvas
30″ x 45″
1869
The Phillips Collection, Washington, D.C.

The Lago di Albano, a lake in the shape of a crater, is located about twelve miles southeast of Rome. Inness found it an intriguing subject and painted its many aspects repeatedly. The Mediterranean qualities of the scene are enhanced by the tall stone pine and a group of cypress trees in the background.

In the spacious meadow in the foreground, more than a score of holiday-makers congregate informally in small clusters. Clearly, this scene—reminiscent of an Italian opera as the curtain goes up on the first act—was invented by the artist. This large number of people, some of them in lively motion, is unusual for Inness. He rarely put more than two figures into a painting, and then only to serve as focal points of color and as a human scale to emphasize the magnitude of the landscape—mountains, rocks, trees—depicted.

Inness' figures are generally sketched in the most summary fashion. Here, however, they are better defined, their garments are carefully rendered. The faces cannot, of course, be seen distinctly; characterization is achieved by posture and gesture. The eloquent choreography of stance and movement makes this painting as dramatic as a Flemish or Dutch peasant scene.

40

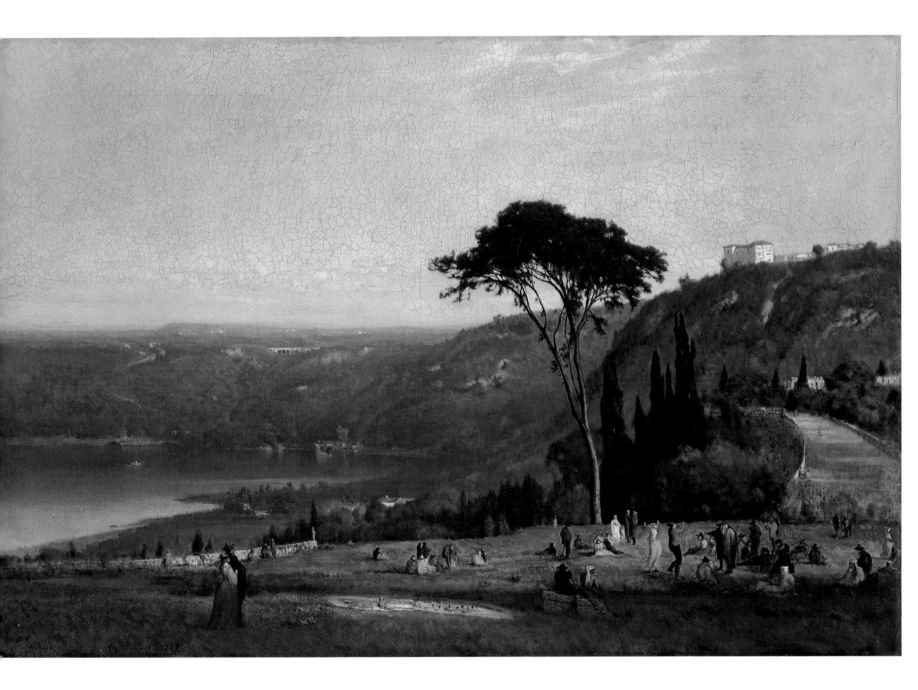

Plate 11
CATSKILL MOUNTAINS
Oil on canvas
48¼″ x 72½″
1870
The Art Institute of Chicago, Chicago, Illinois
Edward B. Butler Collection

This picture is one of twenty-eight works by Inness that are owned by the Art Institute of Chicago. Most of them were donated by a Chicago businessman, Edward B. Butler, who devoted his leisure hours to amateur painting. After paying tribute to Mr. Butler's "public-spirited generosity," the artist's son goes on to describe *Catskill Mountains:*

"[It] shows an afternoon sun pouring down from behind blue clouds, tipped with opalescent light, which is thrown across the mountain-range, permeating the whole scene. The style of it is very similar to 'Peace and Plenty,' and shows his earlier methods. You will notice that everything is made out with minute delineation. Every tree is painted individually and stands apart, this elaboration being carried from foreground to distance."

George Inness, Jr. calls attention to the "wonderful envelopment and charm of light" in this work of his father.

George Inness, Sr. was not the discoverer of this region, however. As early as 1826, a magazine, praising the wonders of the Catskills, exhorted Americans not to "leave their native country for enjoyment when you can view the rugged wilderness of her mountains, [and] admire the beauty of her cultured plains." Somewhat later, it became fashionable to interrupt the standard steamboat trip up the Hudson River valley with a stagecoach jaunt to the Catskill Mountains. Washington Irving extolled the charms of the region; Thomas Cole had a studio there and resided in the Catskills both summers and winters.

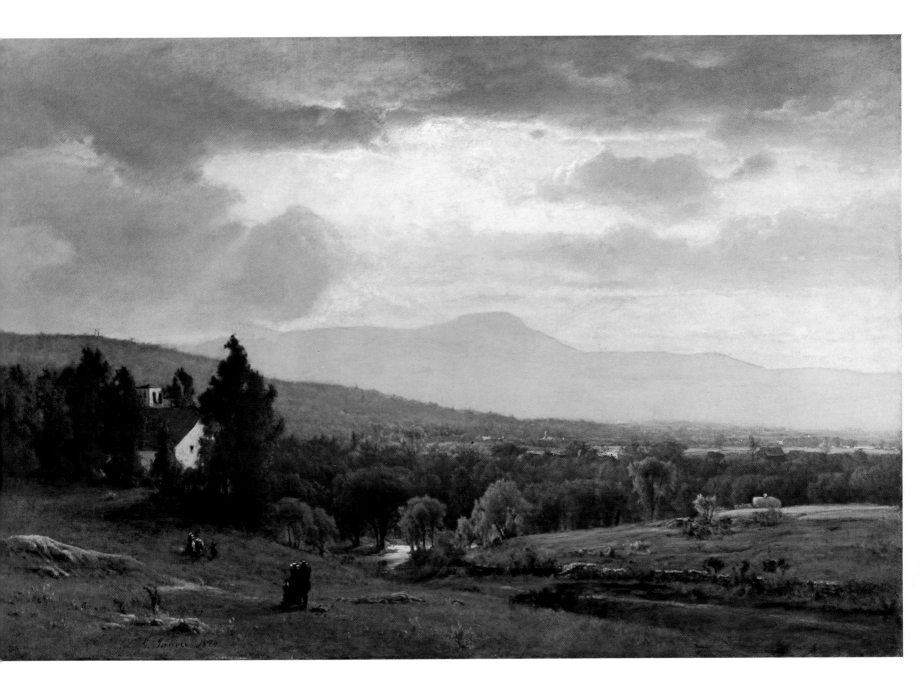

Plate 12
MONTE CASSINO ABBEY, ITALY
Oil on canvas
38″ x 63″
1871
Baylor University Art Museum, Waco, Texas

This picture is a product of Inness' third European sojourn (1870–1875). We are told by his biographer Nicolai Cikovsky, Jr. that "this third European trip was made not for purposes of study but as a business venture in collaboration with his dealers, Williams & Everett of Boston, who received all of his European paintings, with the exception of those he sold in Europe, apparently in return for regular payments." The New England sage Ralph Waldo Emerson had asked: "Nature being the same on the banks of the Kennebec as on the banks of the Tiber—why go to Europe?" Yet wealthy American art patrons in the post-bellum years preferred pictures with European subject matter for their fashionable drawing rooms, and Inness found a way to satisfy their needs.

The Abbazia di Monte Cassino was built on an isolated hill, about midway between Rome and Naples. The monastery—the cradle of the Benedictine Order established in the early Middle Ages—is one of the richest in the world and became the metropolis of Western monasticism and one of the holy places of Roman Catholicism. It was destroyed four times; since the last destruction, during World War II, it has been completely reconstructed.

In this picture, the Abbey, set high on a hill, is silhouetted against the sunset sky. While the artist repeated many of his motifs, there is no evidence that he ever returned to this subject again. In the painting, more attention is paid to the foreground—the man on horseback, the cattle, the grove of olive trees—than to the Abbey and its architecture.

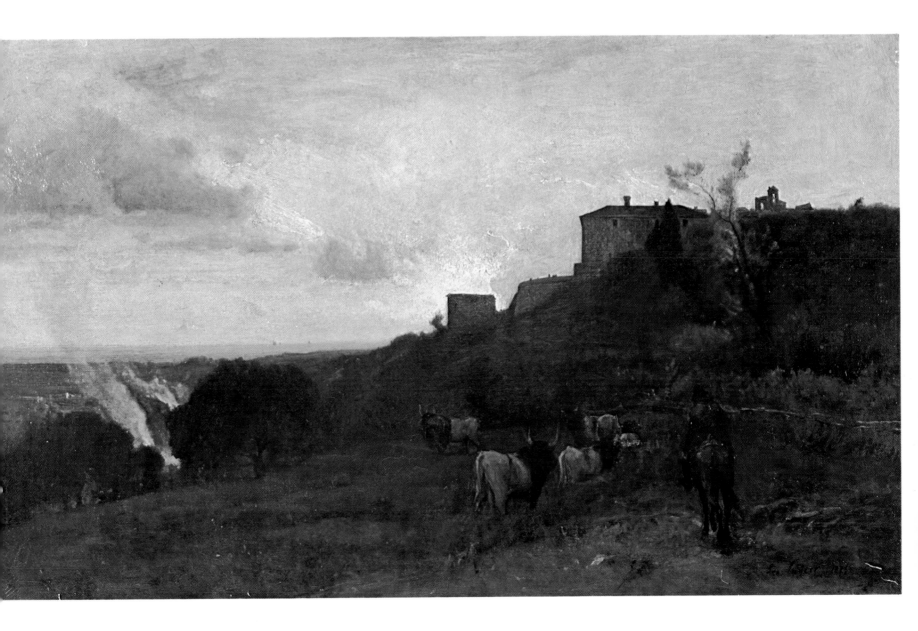

Plate 13
IN THE ROMAN CAMPAGNA
Oil on canvas
26" x 43"
1873
The St. Louis Art Museum, St. Louis, Missouri

This picture is very similar to one entitled *Sacred Grove near Rome,* painted in 1872, and now in a private collection in Pittsburgh. Altogether, there are at least three works by Inness that feature this sacred grove (here, the cluster of trees left of center). In the picture that is now in St. Louis, as well as in the one in Pittsburgh, buildings of the Eternal City can be spotted in the distance. The large structure is the famous Basilica of St. John in Lateran, located on a hill in the easternmost section of the city.

The soft blue sky covers more than half the canvas. A sharp color accent is produced by the woman's red kerchief. The painting is faithful to the atmosphere of the Campagna, and is certainly more plausible than Plate 1, which is more romantic, more idealized, in spirit. Everything is very carefully painted and suggests the early rather than the late manner of Corot: that is to say, his firmly and clearly painted Italian landscapes rather than his final woodland scenes, where the vision is more misty and blurred.

One is also reminded of seventeenth-century Dutch artists—such as Jan van Goyen, Aelbert Cuyp, Salomon van Ruysdael, Jacob van Ruisdael, Jan Wijnants, and Meindert Hobbema—who painted panoramic views in which vast plains stretch out endlessly, while as much as four fifths of the canvas may be given over to the sky, empty except for some interesting cloud formations. Like these Dutchmen, Inness often placed shadows, apparently created by clouds, in the foreground to break up the space and thereby to eliminate monotony. These clouds, producers of the dark spots on the ground, did not necessarily exist; yet Inness' arbitrary method of inventing forms of light and forms of darkness always yielded convincing results.

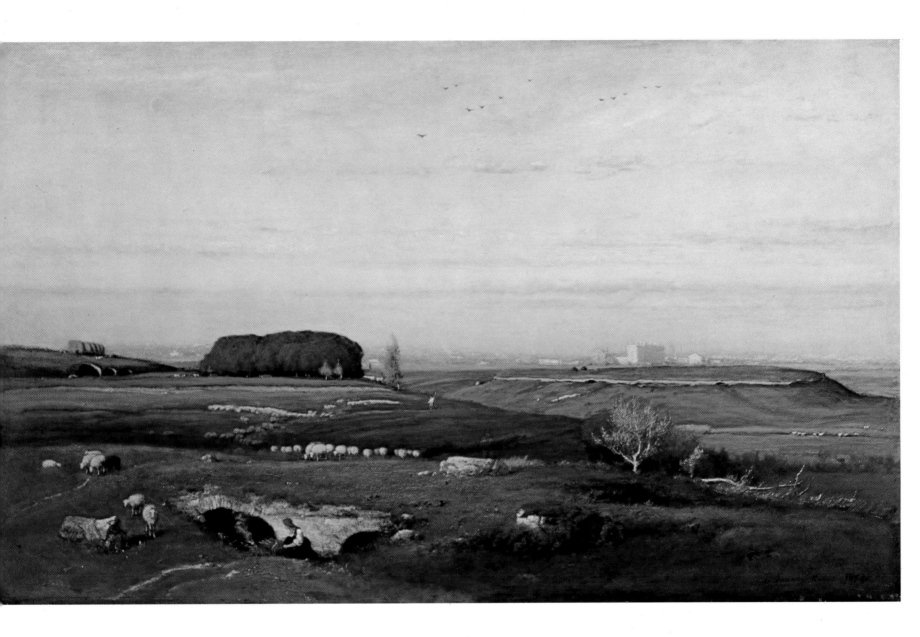

Plate 14
THE ALBAN HILLS
Oil on canvas
30⅞" x 45¹⁄₁₆"
1873
Worcester Art Museum, Worcester, Massachusetts

Like Lake Albano (Plate 10), the Alban Hills are located some miles southeast of Rome. Inness created an interesting composition by the use of several clever devices. A lighted area—the road—thrusts into the dark foreground like a dagger. The trees, forming a band in the center, are largely shadowed. Yet, through openings—one large, several others small—the sunlit space in the background can be glimpsed.

This is another instance of a "panoramic landscape," where excellent use is made of perspective. The spectator is invited to enter the picture and to join the different figures, strategically placed to animate the composition and to emphasize the dimensions of trees, rocks, and pieces of masonry. Movement is produced by the gently undulating forms on the ground, and by the Turneresque swirls of clouds in the magnificent sky.

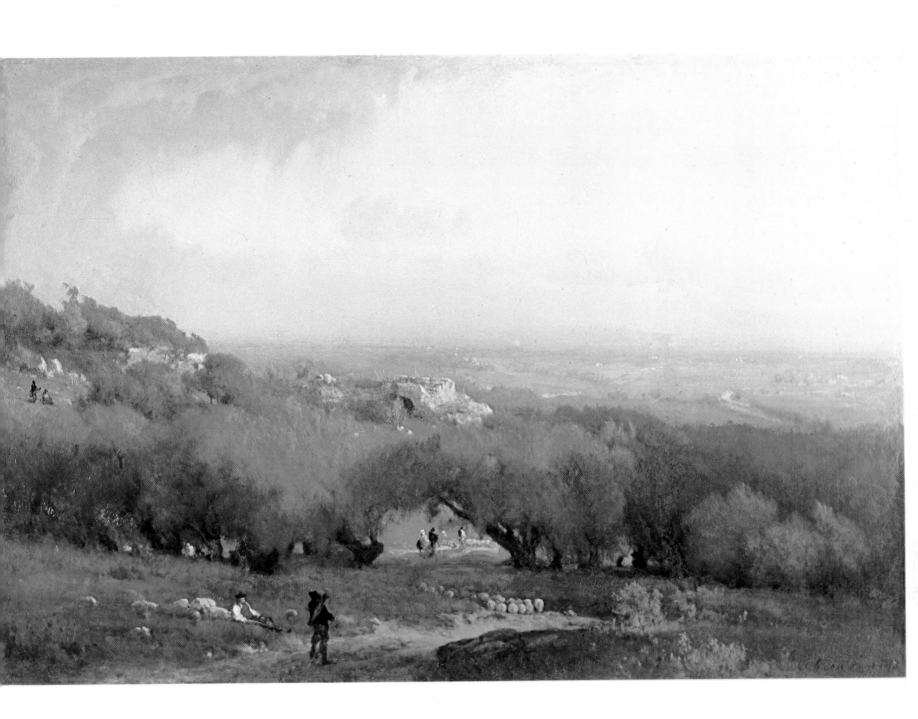

Plate 15
THE PINES AND THE OLIVES
Oil on canvas
38½″ x 64½″
1873
Addison Gallery of American Art,
Phillips Academy, Andover, Massachusetts

This picture, also called *The Monk,* or *The White Monk,* was painted from the Barberini Villa at Albano, not many miles from Rome. The Barberini were a powerful Italian family of Tuscan extraction; they held much property, and one of them was raised to the papal throne. One is reminded here of Washington Allston's Italian landscapes, filled with romantic poetry rather than topographical detail. The tiny figure of the white-robed, hooded monk, who seems lost in meditation, introduces a note of mystery. The monk is seen moving away from the center, as though leaving the scene; one would have expected a painter to make the only figure march into the picture rather than out of it. A weird, almost uncanny, atmosphere is also produced by the combination of the crepuscular light and the large trees thrusting their branches horizontally against the evening sky.

This is not a very typical Inness work, though reddish skies do appear ocassionally in his pictures. It is rather well-structured, divided as it is into horizontal stripes by orange bands of the evening light that flushes against the funereal, umbrella-like pines. The foreground is rather dark, and whatever details were painted in are not easily recognizable. *The Pines and the Olives* expresses well the artist's inherent religious mysticism, and is one of his most haunting compositions. Inness knew well that he had two opposing styles, "one impetuous and eager, the other classical and elegant," in his own words. Here, he was able to combine the two most successfully.

It is pictures like this, or *Stone Pines* (Plate 16), that seem to justify James Jackson Jarves' reference to Inness as "the Byron of our landscapists." For there is something utterly romantic about this oil, with its spooky and weird quality that recalls the German romantic painter, Caspar David Friedrich, but also has features that might be termed Surrealist.

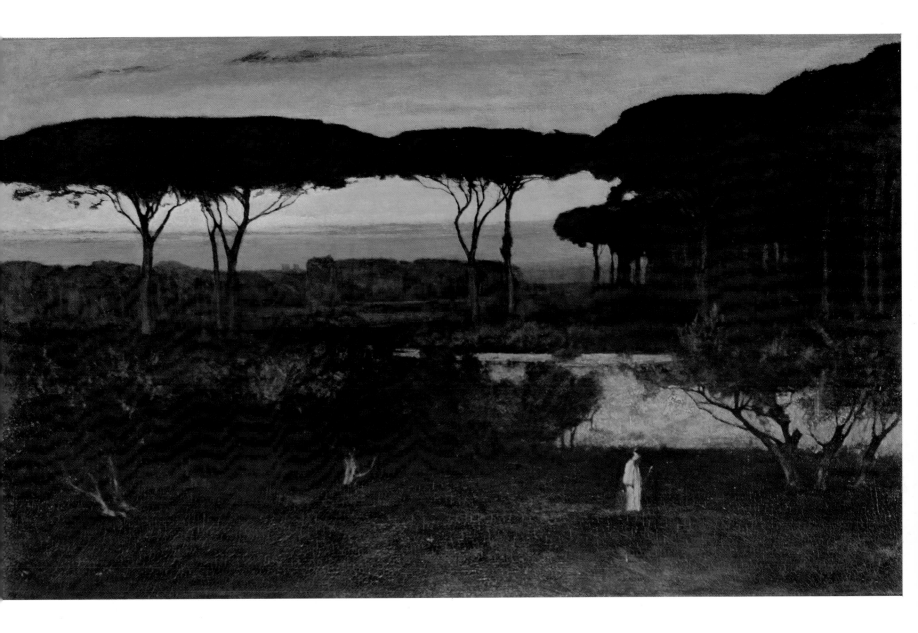

Plate 16
STONE PINES
Oil on canvas
30" x 45"
1874
Virginia Museum of Fine Arts, Richmond, Virginia

This picture is also known as *Pine Grove, Barberini Villa, Albano, Italy*. Inness loved to paint all kinds of trees, whether oaks or elms, cypresses or pines. He would have agreed with Théodore Rousseau, for whom trees were images of permanence, and who said that they were for him "great history, that which will never change." The Barbizon master added: "If I could speak their language, I would be using the tongue of all ages."

This picture has similarities to the preceding one. Drama is created through the juxtaposition of the dark, flat shapes of trees in the foreground, whose cool colors make them recede, and the hot colors in the background, which seem to move toward the onlooker. Tension is created by the shapes of the tall, very Mediterranean trees and the intricate patterns produced by the branches on the right. The foreground is not entirely dark: there are several tiny lighted areas. All of this might be the stage for the enactment of a fairy tale, or the *mise-en-scene* of an old-fashioned Italian opera.

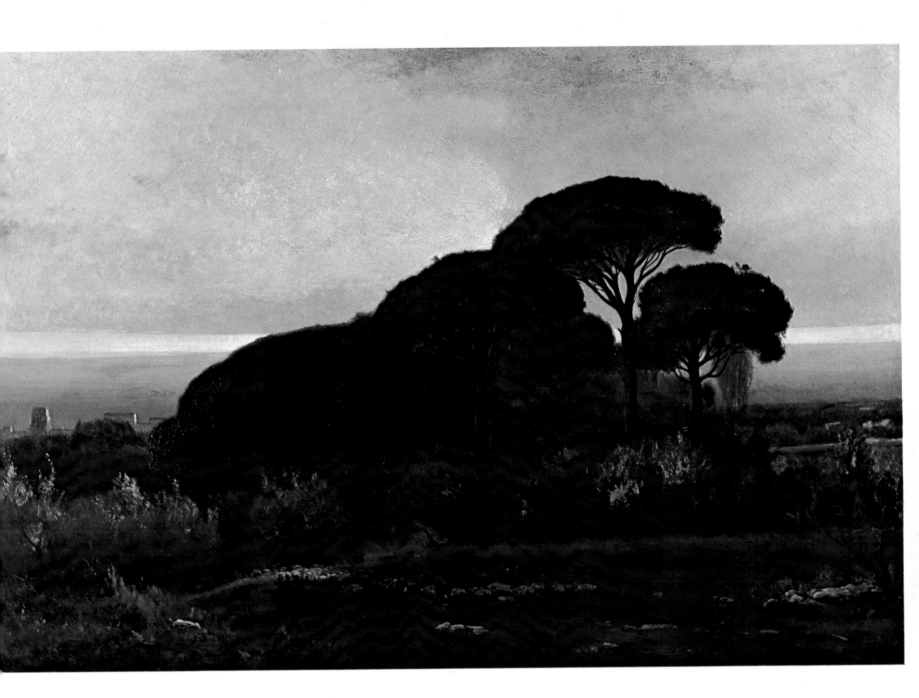

Plate 17
ETRETAT
Oil on canvas
30″ x 45″
1875
Wadsworth Atheneum, Hartford, Connecticut
Ella Gallup Sumner and Mary Catlin Sumner Collection

Inness painted more than twenty pictures based on Etretat, a watering place on the northern French coast sixteen miles from Le Havre, where the Seine River pours into the Channel. He was not the first artist to be attracted and fascinated by its fantastic arched cliffs. Gustave Courbet spent some time in Etretat; the Louvre treasures his *Cliffs at Etretat after the Storm* (1869–1870), in which he puts the emphasis on the massiveness of one rock formation. Claude Monet, repeatedly painting the same motif, preferred to capture the sun's violet reflections on it, and the shimmering humidity of the atmosphere. In his pictures, Monet brought out the forces of nature, the rolling surf, the wild waves; Courbet painted several pictures of the stormy sea at Etretat, but without the rocks.

Though Inness was aware that his reputation was founded on landscapes, he may have felt that this seascape motif might find eager buyers. The majestic lower cliff—the immense gray block of granite over two hundred feet high—has been gradually eroded by the tides to form an arch and a needle that is not visible here. In contrast to several other Etretat pictures by Inness, the emphasis here is not on the natural bridge, the rocky gateway extending into the sea, but on the smiling, bucolic landscape and the calm blue waters in the distance. Chromatic accents are offered by the red kerchief, white cloak, and blue-gray skirt of the woman walking through the meadow with a companion. The chimneys of the village are half-hidden by the trees.

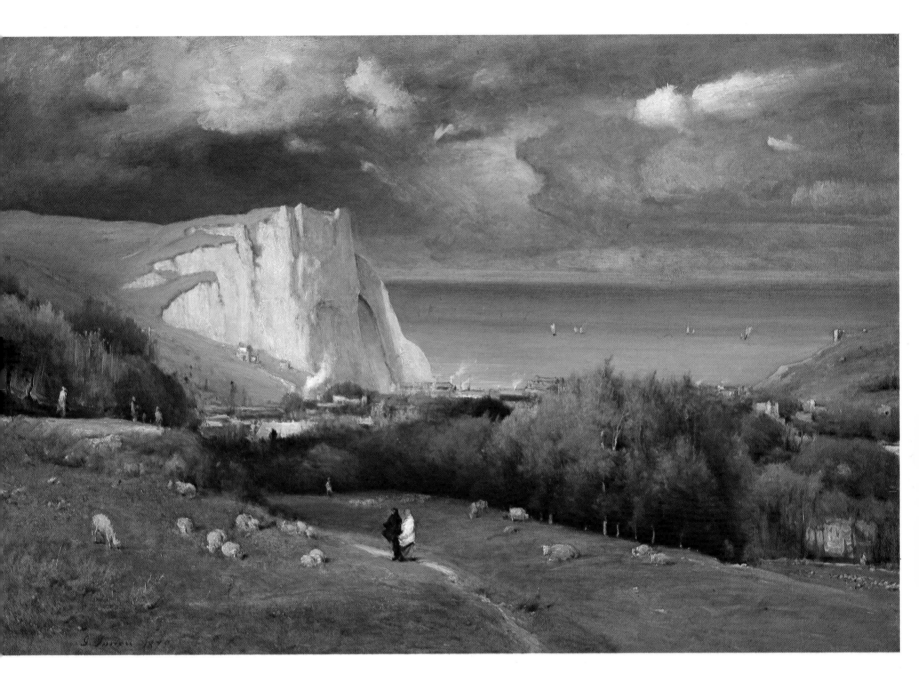

Plate 18
SCENE IN PERUGIA
Oil on canvas
38½″ x 63½″
1875
Museum of Fine Arts, Boston, Massachusetts

In the last century, Perugia was, for a while, host to a colony of American artists, of whom the best-known was Elihu Vedder. Situated on a group of hills above the valley of the upper Tiber, Perugia attracts visitors by its art treasures and medieval atmosphere. Inness painted Perugian scenes perhaps a dozen times. However, one cannot always be sure that it is not another place that is offered to our eyes, despite the title, which may have been provided by a dealer. "The subject is nothing," Inness once remarked, after having turned a seascape into a landscape. To a purchaser who inquired, "What part of the country is this a picture of?" the artist replied angrily, "Nowhere—I do not illustrate guidebooks. This is a picture."

The tall trees and the buildings atop the hill form the background for animated life, with a woman bent over a water trough washing clothes, two figures conversing nearby, and two priests walking uphill. The trees are artfully set against the sky, which has a circular movement of dark clouds. The picture is also known as *Rainbow Over Perugia*.

The scene with the three peasant women makes one speculate whether Inness might not have become a good genre painter, had he so desired. He was a contemporary of Eastman Johnson, who specialized in this sort of painting. Apparently, this was not to Inness' liking, though anecdotal conversation pieces were much in demand during his lifetime. Pictures in which people dominate the scene, rather than playing a subordinate role, are rare in his total *oeuvre*.

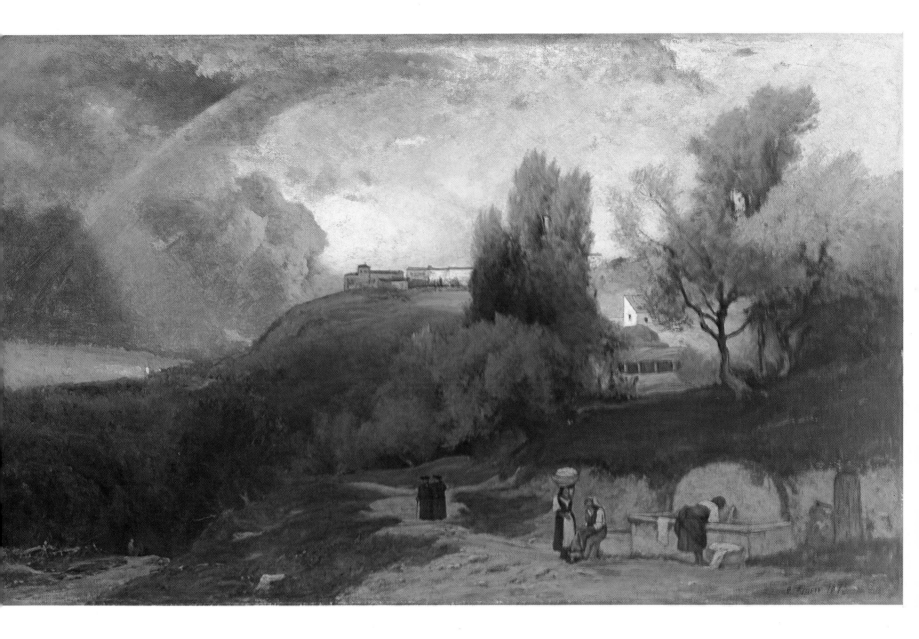

Inness, who found cloud effects particularly congenial, liked to paint landscapes showing a moment when dark clouds accumulate and foreshadow a thunderstorm. There are numerous pictures on this theme, as he was fond of "a continued repetition of the same thing in a different form and in a different feeling." The locale may be the Roman Campagna, the Delaware River valley, the Berkshire Mountains, Montclair (New Jersey), or an unidentifiable spot. Here, the topography is reminiscent of that in Plate 13, where grazing sheep can also be observed below a grove of trees. The shepherd sits on the grass, stoically unmoved, though a downpour might descend any minute.

This very forceful picture is the work of a man possessed by passion, and even violence. Despite his frailty, Inness is known to have worked at a furious pace, to have lived in a frenzy of vigor, and to have literally attacked his canvases in the heat of creative urge. "In his studio he was like a madman," his son relates. After a long preparation for the task, he was finally ready for it: "With a sudden inspiration [he] would go at a canvas with the most dynamic energy, creating the composition from his own brain, but with so thorough an underlying knowledge of nature that the keynote of his landscapes was always truth and sincerity and absolute fidelity to nature."

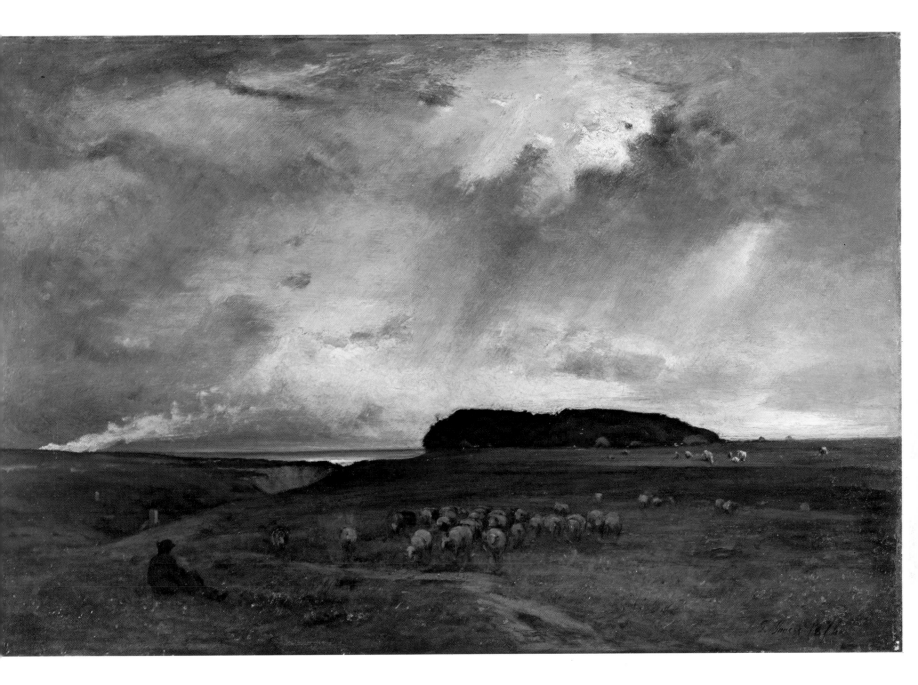

Plate 20
ALEXANDRIA BAY ON THE ST. LAWRENCE RIVER
Oil on millboard
16″ x 24″
1878
The Art Institute of Chicago, Chicago, Illinois

This view is from the American side of the river, near the Thousand Islands in upstate New York.

Alexandria Bay is a very small picture, not nearly as finished as other oils by Inness. It seems to be a sketch, done quickly. In most cases, the artist painted on canvas. Here, he used a bit of millboard, a composition board made of wood pulp, and he may have worked on it outdoors rather than in his studio. Patches of light are distributed wisely throughout the picture, and emphasis is placed on the fascinating patterns of the trees reaching high into the sky, the coloration of which suggests the effect of evening.

The rapidity of execution is suggested by the scrubby brushwork, particularly in the sky, where the strokes are applied so quickly that the color of the underlying painting surface appears through them. The figures in the foreground are hardly more than spots of color, with no indication of detail. The thick strokes in the immediate foreground were obviously dashed in wet-in-wet, without any attempt to blend them. Notice how few strokes were employed to render the standing figure on the edge of the shore to the viewer's left.

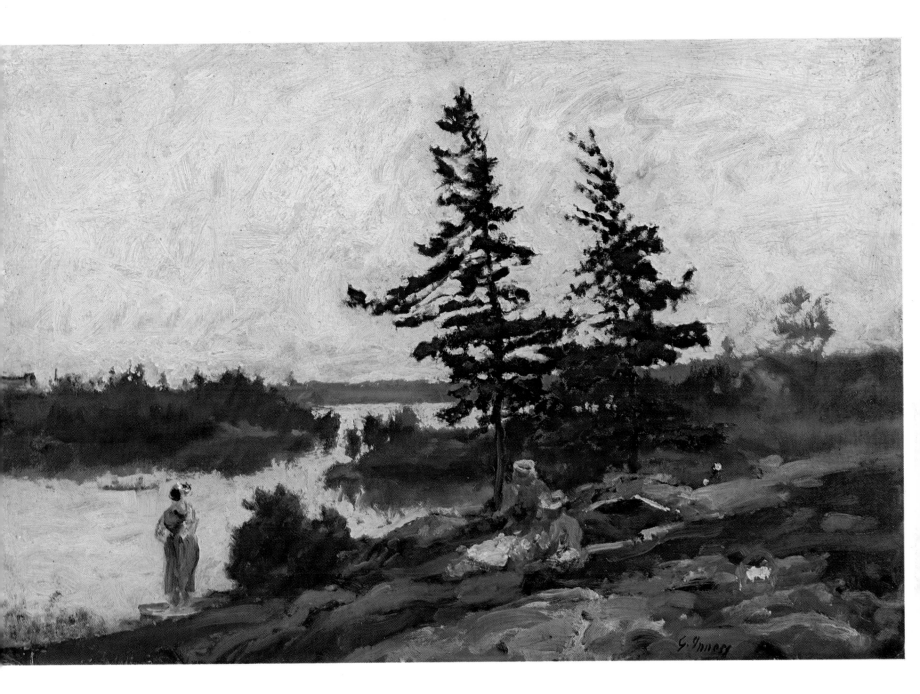

Plate 21
THE COMING STORM
Oil on canvas
26″ x 39″
1878
Albright-Knox Art Gallery, Buffalo, New York

While the foreground is filled with sunlight, the storm clouds loom in the background like a menacing gray wall. Inness succeeded superbly in producing the effects of that weird light which precedes the expected storm, when the last rays of the sun catch the trees. Here, the mature artist's treatment of the trees, his spontaneous handling of essentials, is so very different from that of his youth (see Plate 1), when he tried to paint every detail, even every leaf. He summarizes here, suggesting rather than literally describing. In this strongly unified composition, the interplay of the dark gray storm clouds with the fresh, vivid light green of the fields is well shown. The swaying branches of the trees appear to be waiting for the storm to strike them.

A picture done in strong color yet free brushwork, it expresses the artist's belief that his goal was "not to imitate a fixed material condition, but to represent a living motion." It is not astonishing that pictures of this kind were admired by the outstanding critic and collector James Jackson Jarves, who wrote of Inness: "We can breathe in his atmosphere and travel far and wide in his landscape."

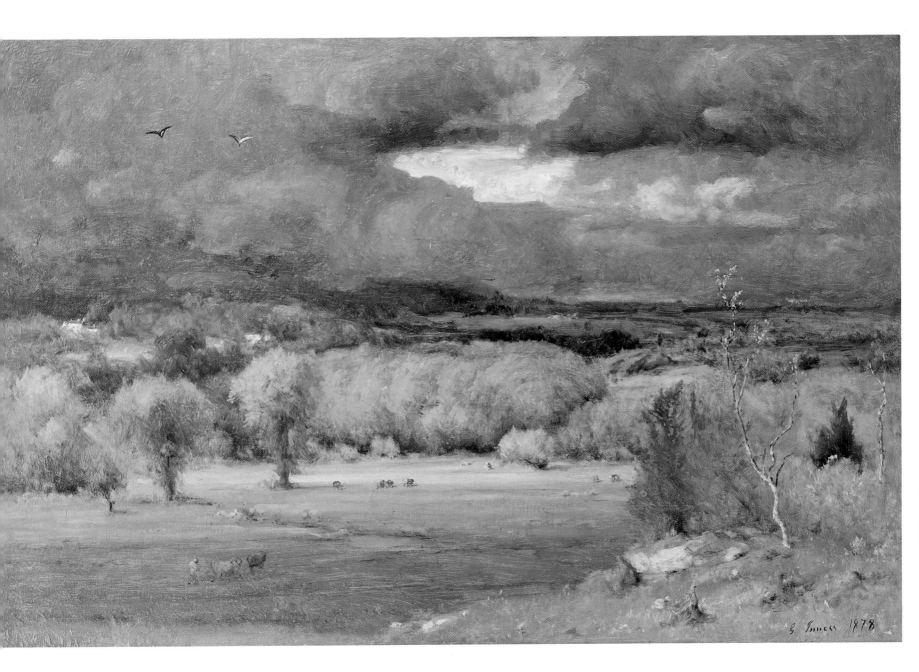

Plate 22
WINTER MORNING, MONTCLAIR
Oil on canvas
30″ x 45″
1882
Montclair Art Museum, Montclair, New Jersey
Gift of Mrs. Arthur B. Whiteside

In 1878, Inness and his wife moved permanently to Montclair, situated at the base and on the slopes of the Orange Mountains in Essex County. While it was even then a well-established old community—it is now virtually a residential suburb of New York City—Inness was not attracted by the urban aspects of the town, but rather by the nearby farms, fields, orchards, and forests. His son recalls that, having acquired a dealer who managed his business affairs excellently, the artist now found himself "in the full attainment of a position of ease." Settling in Montclair, he bought a homestead on Grove Street:

"He built a studio and painted as he had long desired, unhampered by commercial and financial cares. But the end of his struggles did not mean the end of his usefulness. Far from it; for he painted up to the time of his death, and in the last few years of his life he developed a breadth and technic [sic] in his work which closely correspond to the breadth of his mental and spiritual unfolding."

From this rather small canvas, one gets the impression that he is viewing the scene from a window. While little snow is to be seen, the whole of the winter seems to be summarized in the skeleton of the fallen tree in the center. There is only one figure in the picture—that of a woman picking up branches of storm-shattered trees.

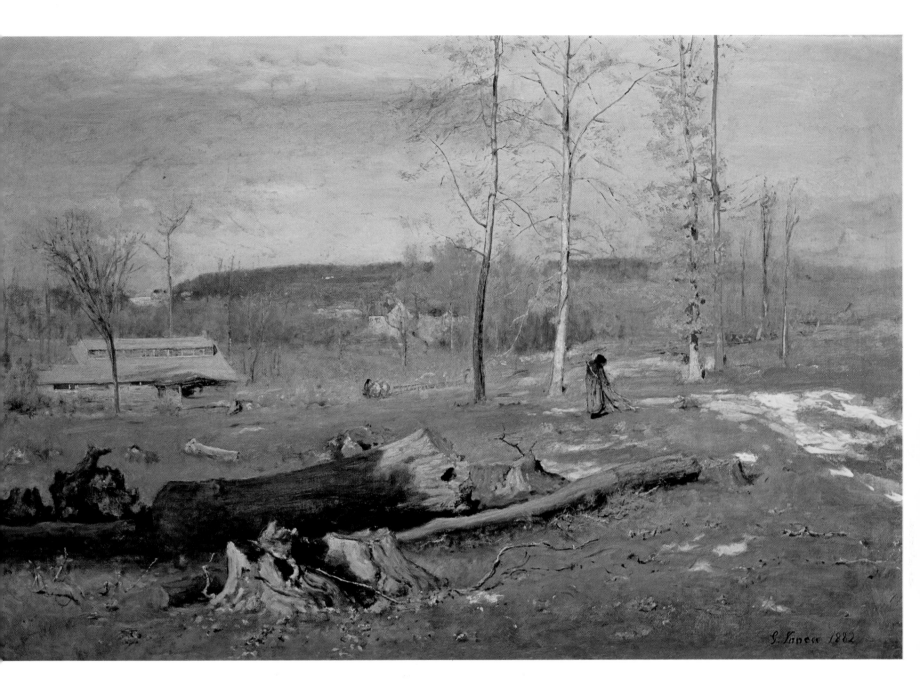

Plate 23
APPLE BLOSSOM TIME
Oil on canvas
27" x 22"
1883
Pennsylvania Academy of the Fine Arts, Philadelphia, Pennsylvania
Bequest of J. Mitchell Elliot

This motif of fruit trees in bloom occupied many of the Impressionists and Post-Impressionists who were Inness' contemporaries, among them Pissarro, Sisley, Cézanne, and Van Gogh. The latter worked on a series of orchards during his stay in Provence. But Van Gogh's work was barely known anywhere during Inness' lifetime, and the Japanese treatment of the theme—on hand-painted folding screens—was not widely known in the United States.

Here, Inness has produced, with a light hand, a very delicate picture that is like a dream, and as charming as anything of this sort created in Europe or Asia. Of a rather similar picture, *Spring Blossoms, Montclair, New Jersey* (The Metropolitan Museum of Art, 1889), George Inness, Jr. has written:

"He has left the wild riot of the autumn color to sit beneath the appletree and watch the blossoms as they tremble in the sleepy sun that is warming up the earth, and throws an opalescent light on all about. See the delicacy of touch. He has been afraid to touch even the pencil-marks for fear of one harsh note that might disturb the blush and make the petals fall."

The picture is divided into three bands of color. All action is confined to the central band; the trees grow out of the foreground in a rather ghostly fashion. Edges are blurred, softness prevails, with very little being defined in a linear way.

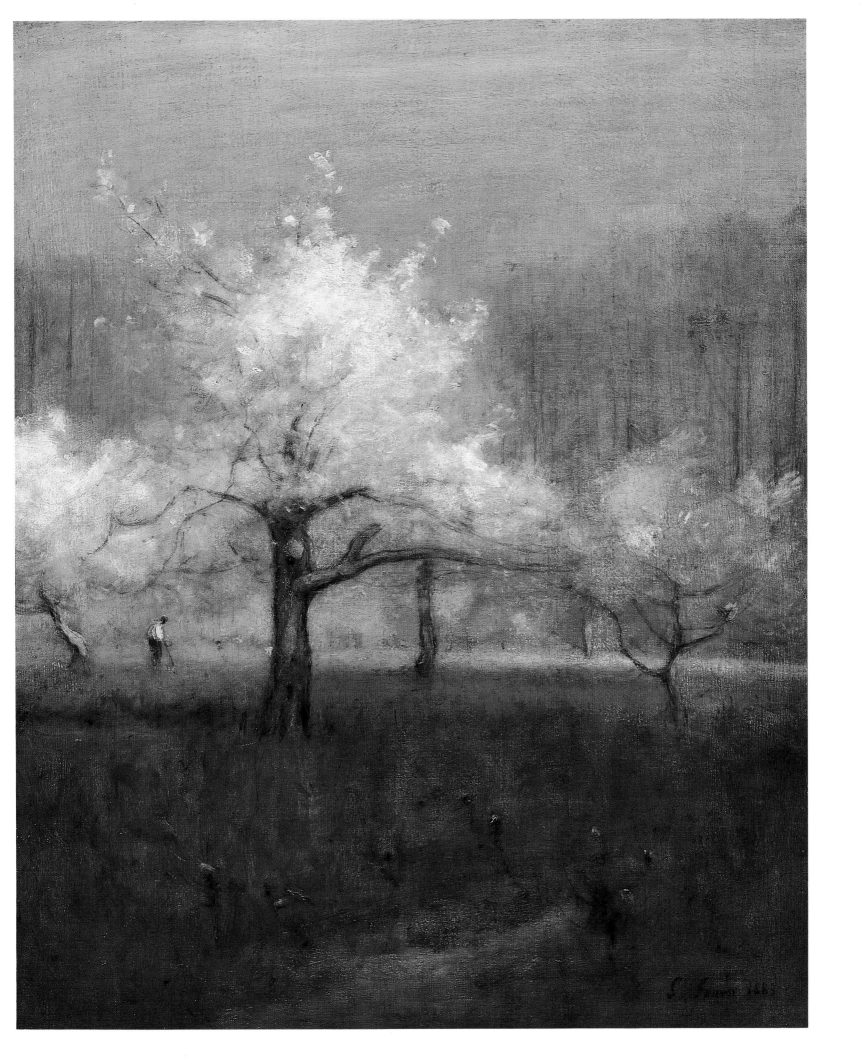

Plate 24
NIAGARA FALLS
Oil on board
16" x 24"
1885
Montclair Art Museum, Montclair, New Jersey
Presented by Mrs. Florence O. R. Lang

Inness made several small paintings of the Falls before and after creating the large, 48 x 72 inch *Niagara Falls* (private collection, New York State) in 1884 for his friend Roswell Smith of New York City, founder of the *Century Magazine* (who was to become George Inness, Jr.'s father-in-law).

This motif is one of the most popular, painted or photographed, in the United States. It inspired John Vanderlyn, Thomas Cole, Frederick Church, Joseph Pennell, John Henry Twachtman, and other American artists. In 1847, Cole noted in his journal: "The beauty of Niagara is truly wonderful, and of great variety. Morning and evening, noon and midnight, in storm and calm, summer and winter, it has a splendor all its own. In its green glancing depths there is beauty and also in its white misty showers. . . ." He ends his rhapsody with these words: "Favored is the man who treads thy brink. Thankful should he be to God for the display of one of His most wonderful works."

This small canvas conveys as effectively as the much larger one the idea of the Falls' majesty, the cataract's irresistible power. It is a forceful study in white, green, and brown. Uninterested in mere description, the artist focuses on the clouds of mist and vapor boiling up from the great caldron, and struck into chromatic splendor by the sunlight. The two figures on the right look rather puny in the face of the sublime spectacle of nature. The whiteness of the foam is heightened, framed as it is by the dark trees and the cloudiness of the sky.

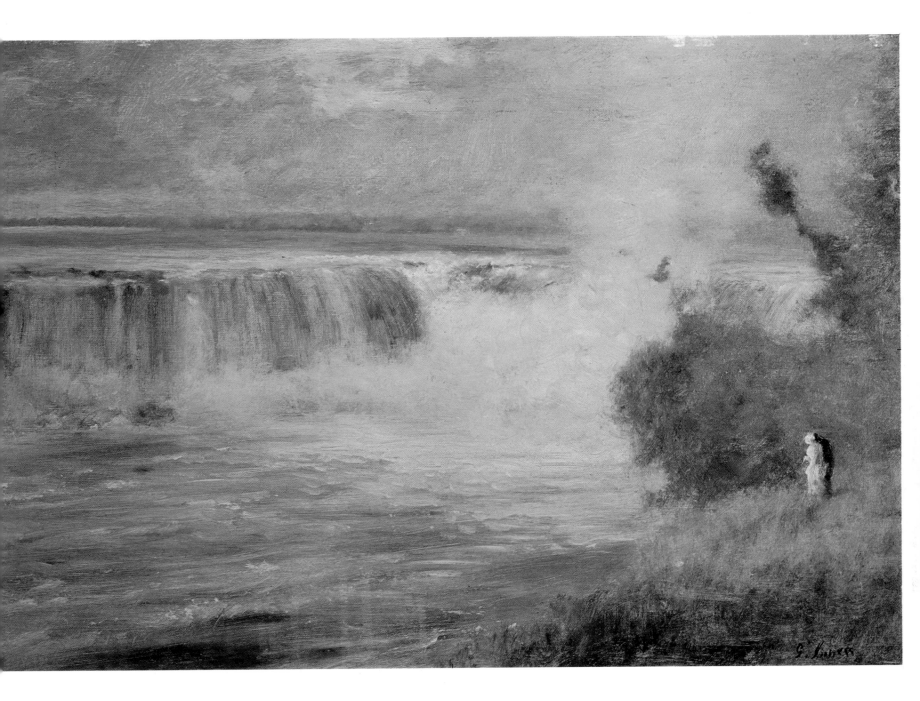

Plate 25
ETRETAT, NORMANDY, FRANCE
Oil on canvas
30″ x 45″
1885–1887
The Art Institute of Chicago, Chicago, Illinois

The earlier view of Etretat (Plate 17) unmistakably presents certain celebrated characteristics of the local-ity and the cliffs. People and cattle appear, and the nearness of a town is made obvious. Here, however, nothing but rocks and cliffs and a sweeping sea can be noted. (There appears to be a village or town in the background, but its presence is only dimly indicated.) Were it not for the title, one would not know where Inness had chosen his subject. The light is that of either early morning or evening, to judge by the reddish sky just above the beachline. The only animate objects are two birds in flight.

The remarkable strength in this rendition of the greenish sea and the white foam indicates that Inness could have become one of the foremost marine painters of his time, had this been his desire.

One is reminded of *The Pine and the Groves* (Plate 15), as here, too, there is a clash between the coolness of the dark foreground, and the "heat" created by the strong chromatics in the background. Wisely, the artist restricted the hot colors to a small area. A completely red or orange sky would have been bound to create an unpleasant, melodramatic effect by dint of its overabundance.

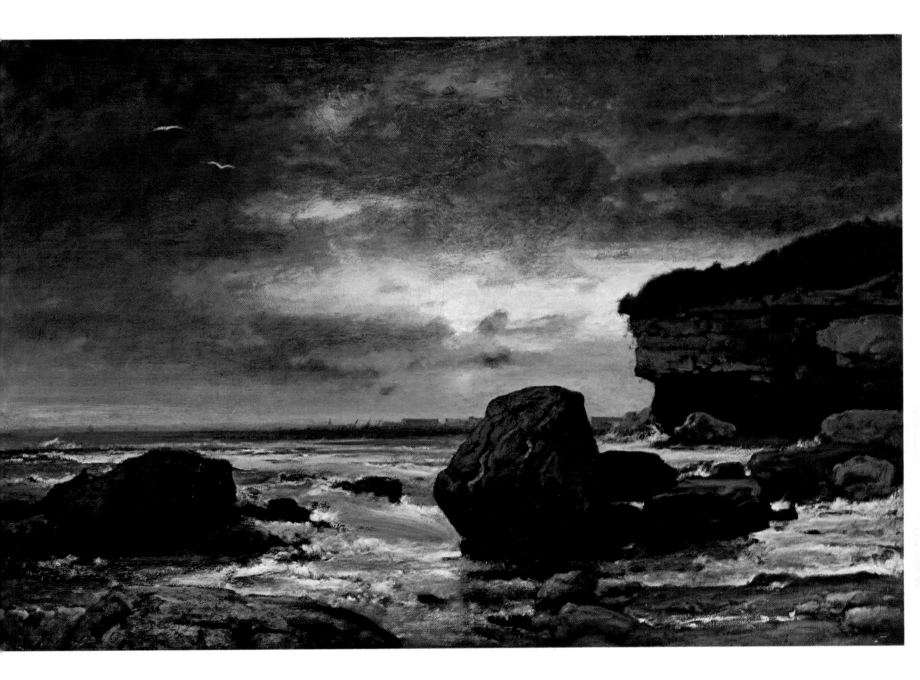

Plate 26
OCTOBER
Oil on panel
20″ x 30″
1886
Los Angeles County Museum of Art
Paul Rodman Mabury Collection

This is a fine example of Inness' late style, perfected in the final decade of his career, when his pictures superbly expressed the artist's pantheistic absorption in nature. While some critics object to his earliest work because the artist tried to give too many details, there were others who felt that the paintings he produced from *ca.* 1884 onward were not sufficiently "finished"; that they were somewhat rough and sketchy by the accepted standards of the time. Indeed, in some of the pictures solid form dissolves in the aura of light and soft atmosphere. A picture like *October* is "realistic" only in the most general way. The composition is carefully ordered; the canvas seems divided symmetrically into four rectangles; the space arrangement and the choice of colors are calculated to produce effects of stillness, of peacefulness, rare in nature itself. Yet while a view like this probably did not exist, and certainly not exactly in the way it is shown here, the picture is highly believable.

Some slight narrative content exists in some of Inness' earlier pictures; in this late one there is none. The scene is reduced to an open green space with water in the foreground, a few trees, and the sky. Human presence is reduced to a single figure of a woman, and to some dwellings in the distance. The protagonist is the light which unites all the elements: the marshy foreground, the water, the foliage of the trees.

The picture might carry as a subtitle these lines by Shelley:

> "There is harmony
> In Autumn, and a lustre in its sky
> Which thro' the summer is not heard or seen."

72

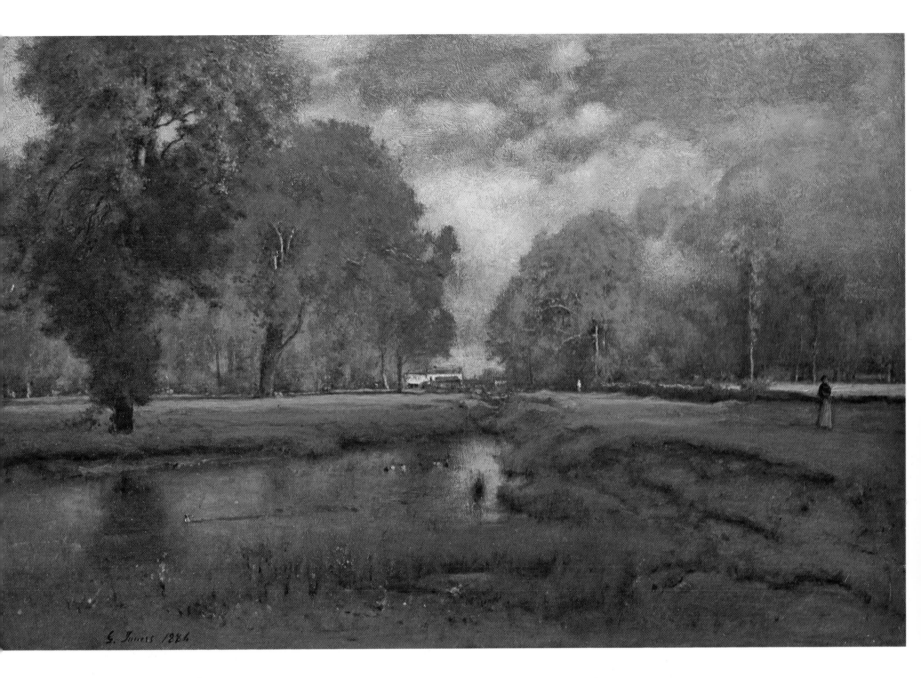

G. Inness 1884

Plate 27
OFF THE COAST OF CORNWALL, ENGLAND
Oil on canvas
25" x 30"
1887
The Paine Art Center & Arboretum, Oshkosh, Wisconsin

Inness traveled a great deal and had a remarkable adaptability to different places and conditions. While the majority of his works were inspired by vistas of the mid-Atlantic States and New England, he was also able to immerse himself in the spirit of Niagara Falls, Yosemite Valley, and Florida, as well as Italy, the Normandy coast, and England. This particular picture was painted during his second visit to England. Although the artist's reputation is built solidly on idyllic landscapes, the dramatic vigor of this portrayal of a stormy coast shows us an entirely different side of his nature, as well as a subject matter as dynamic as that of J. M. W. Turner or Winslow Homer. He lets himself be inspired here by the impact of the avalanches of water thundering and crashing against the big rocks. The high-flung spray of the choppy sea is brilliantly rendered, as are the storm clouds above the turbulent Atlantic Ocean.

This canvas—revealing Cornwall, the long and rather wild promontory of southwestern England—is one of the few pictures by Inness with something of a story in it. Braving the storm, fishermen are putting into shore. Their attempt to land is intently watched by the young woman on the beach next to the boat. A somewhat larger version of the same motif is owned by the Art Institute of Chicago.

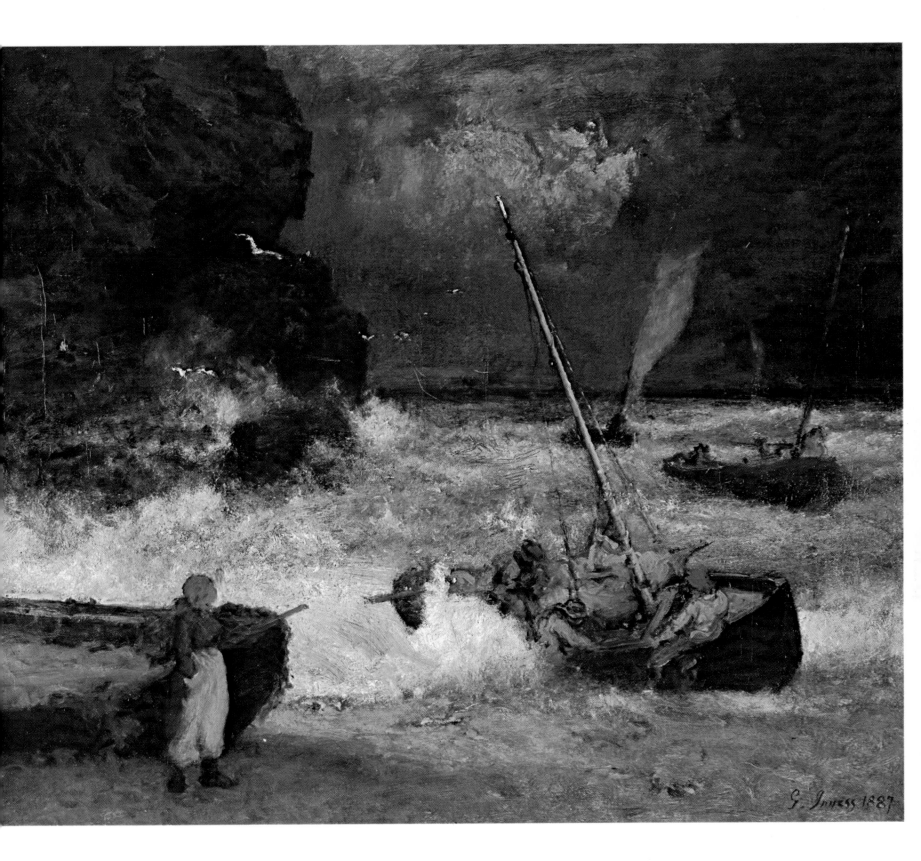

Plate 28
OVERLOOKING THE HUDSON AT MILTON
Oil on canvas
27" x 22"
1888
Nelson Gallery–Atkins Museum, Kansas City, Missouri

Though Inness was born near a Hudson River city, Newburgh, and repeatedly painted the "American Rhine," it is incorrect to list him, as is often done, among the members of the Hudson River School, such as Asher Brown Durand or, in the second generation, Albert Bierstadt. He did not share their entirely romantic attitude toward nature. As a celebrated artist he did, however, spend several summers at Milton in Ulster County, on the western bank of the river, some miles south of his birthplace. There, he lived in a boarding house on a bluff high above the river and had his own studio in an old barn surrounded by an apple orchard.

By 1888, he no longer worked at Milton. In all likelihood, this picture was painted mostly from memory. Yet it is unimportant whether he saw all the elements in the picture—the paddle steamer, the sailboats, the plant stand (a so-called *jardinière*)—at one time. The painting is highly satisfactory, in any case. The artist disapproved of the Impressionists; hence it is amazing how close he came here to their methods of creating an atmosphere of light and movement. A very similar girl in a straw hat also appears in the picture *Poplars at Giverny*, painted by Monet in the same year, 1888.

Plate 29
EARLY AUTUMN, MONTCLAIR
Oil on canvas
30" x 45"
1891
Delaware Art Museum of the Wilmington Society
of the Fine Arts, Wilmington, Delaware

Here we have entered the silent depth of nature. The few trees stand out with peculiar majesty. Judging by the enormous diameter of the trunk, the central tree must be centuries old. Inness, endowed like no one else of his generation with a profound feeling for nature in all her moods, here communicates to us the somber mystery of this cluster of trees, and the expanse of space around it. In the works of his old age, we often notice the quiver of the grass, hear the rustle of leaves, observe the light shed upon the barks of trees. The gnarled tree in the middle has a personality like that of a very old, remarkable man. Indeed, this ancient tree is the hero of the scene, though there are two cowherds visible, and a red barn—a sign of human activity—is seen at the right through the foliage.

It is remarkable how perfectly we are made to feel the "tactile values"—Berenson's term—of the central tree, whose weightiness, solidity, and bigness are emphasized by the relative thinness of the tree placed next to it.

Plate 30
HOME AT MONTCLAIR
Oil on canvas
30″ x 45½″
1892
Sterling and Francine Clark Art Institute,
Williamstown, Massachusetts

Snow scenes have been favorites of artists from Brueghel to Vlaminck, and Inness was no exception. About this picture, George Inness, Jr. has written:

"It was painted just behind the artist's house, where many a field of waving corn and many a green pasture dotted with sheep was painted. But now it is all white; its winter blanket is spread over all, keeping the earth warm until the coming of spring. There is nothing startling in this great work of art, and yet you are filled with a sense of bigness, grandeur, and the very conviction of truth and nature."

This is a very pale picture, economically done. All lines are blurred, everything is still, except for the action created by the two lines leading to the house with the big tree next to it. A lone figure appears near that house, but it is so tiny that it can be overlooked quite easily. Here we have an almost "abstract" composition, carried by the juxtaposition of the snow's whiteness and the reddishness of the evening sky.

Plate 31
MOONLIGHT
Oil on canvas
22" x 27"
1893
California Palace of the Legion of Honor, San Francisco, California
Gift of H. K. S. Williams

Silhouetted against the sky and the foliage of the trees, the brilliant moon appears high in the night sky. Though this is basically a dark picture, the leading role is played by the light—the yellow, golden light of the full moon, and the warm red glow of the lamplight that comes from the window. Note the birdhouse placed on a pole at the right.

This picture made Elliott Daingerfield exclaim: "Can any man of even partial culture remain unmoved in the presence of the great *Moonlight*?"

Night scenes were a specialty of Inness' compatriot and contemporary, James McNeill Whistler, who applied to them the musical term "nocturnes." Night scenes are difficult to paint: the painter has to work within the narrow range of color that the night allows. But he can, as Inness fully demonstrates, make the most of his opportunity to pick up a lighted spot here and there and let flow from it an overwhelming feeling of mystery, of eeriness.

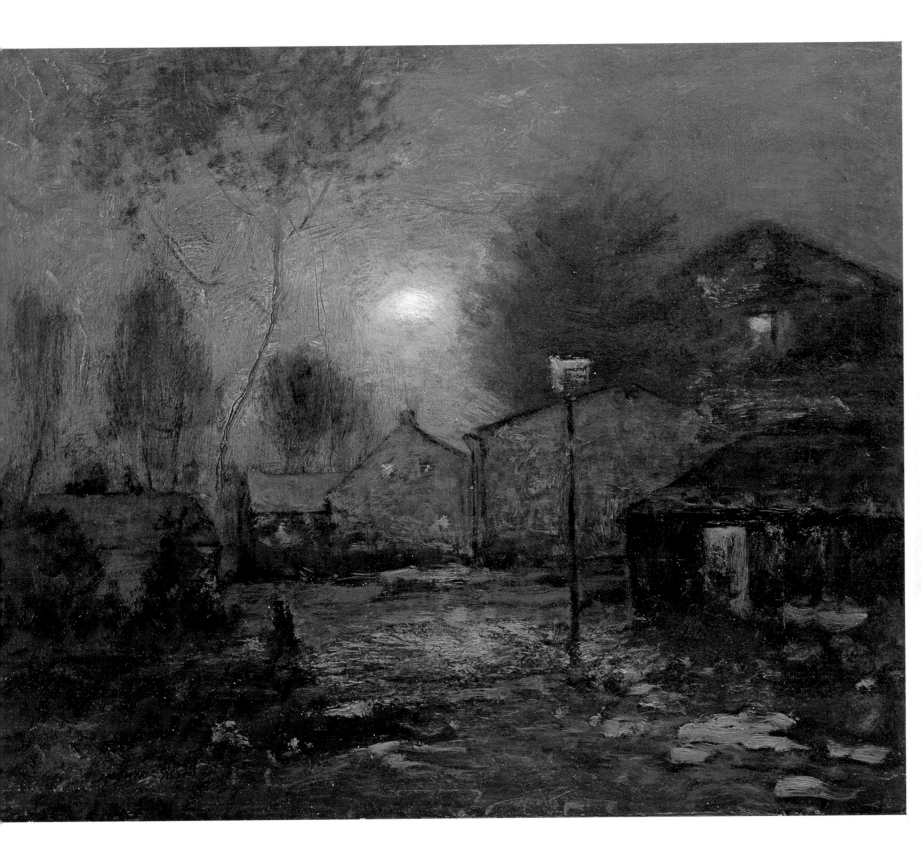

Plate 32
THE RED OAKS
Oil on canvas
36" x 54"
1894
Santa Barbara Museum of Art,
Santa Barbara, California

This picture, also called *Morning, Catskill Valley,* was painted in the artist's final year (he died on August 3), and, in the *catalogue raisonné,* carries the number 1405! It is hard to believe that this was the work of an old man — the artist was in his seventieth year — for the power of construction is unbroken, and the colors glow as vigorously as ever before.

Here, the artist combines the colors and content of the Barbizon artists — whose tree-worship he shared — with broader, more emotional handling of the subject. Referring to a similar picture, *Autumn Oaks* (The Metropolitan Museum of Art), George Inness, Jr. writes: "Was it done from nature? No. It could not be. It is done from art, which molds nature to its will and shows her hidden glory."

Edited by Lois Miller
Designed by James Craig and Robert Fillie
Set in eleven point Fairmont by University Graphics, Inc.
Printed and bound in Japan by Toppan Printing Company, Ltd.